SECRET SOUTHWARK AND BLACKFRIARS

Kristina Bedford

AMBERLEY

In memory of my father Harold, lazy afternoons at The George, and the magic of The Globe.
And, as ever, for Ken, who always has my back.

First published 2019

Amberley Publishing
The Hill, Stroud
Gloucestershire, GL5 4EP

www.amberley-books.com

Copyright © Kristina Bedford, 2019

The right of Kristina Bedford to be identified as the
Author of this work has been asserted in accordance
with the Copyrights, Designs and Patents Act 1988.

ISBN 978 1 4456 7658 6 (print)
ISBN 978 1 4456 7659 3 (ebook)

British Library Cataloguing in Publication Data.
A catalogue record for this book is available from the
British Library.

Origination by Amberley Publishing.
Printed in Great Britain.

Contents

Prologue 4

1. Historic Churches and Religious Houses 6

2. The Black Friars 21

3. Famous Theatres, Then and Now 36

4. Street Life 51

5. Correction and 'Comfortable Works' 61

6. Historic Inns and Industry 77

Epilogue 94

Bibliography 95

About the Author 96

Prologue

The name of Southwark heralds its position as a defensive works south of the City of London. Archaeological excavation has revealed that its Roman settlement was centred on the region flanking London Bridge on the bank of the Thames, with both Roman and medieval river crossings lying roughly 180 feet east of the bridge we know today; its southern boundary corresponded with the current location of St George's Church toward the bottom of Borough High Street. Abandoned to decay at the end of the occupation of 'Londinium', Southwark was reoccupied and created a 'burh' (borough) during the reign of King Alfred the Great, *c.* 886, its fortified Anglo-Saxon bridge used as a key defence in King Ethelred the Unready's battle against the Danish invasion of 1016, and again during the Norman invasion of 1066. William the Conqueror failed to take the bridge but burned Southwark to the ground. His Domesday Survey records that 'Sudwerca' was held by a number of local manors, with the Conqueror's half-brother, Bishop Odo of Bayeux, holding the 'Monasterium' (Minster), originally the Priory of St Mary Overie,

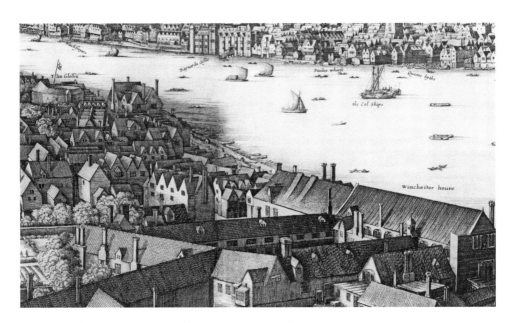

Long view of London from Bankside by Wenceslaus Hollar, 1647.

later destroyed in 'the Great Fire of Suthwark' in 1212. It was rebuilt on the same site as the Cathedral and Collegiate Church of St Saviour and St Mary Overie, more commonly known as Southwark Cathedral.

The thirteenth century also saw a substantial ecclesiastic edifice erected on the northern side of the Thames, as the Dominican Friars – identified by the black cloaks worn over their white habits – moved their Priory from Holborn to the quarter opposite Southwark's Bankside c. 1276. The walls of the Blackfriars presided over great state occasions as well as monastic contemplation and, ironically, a hearing in King Henry VIII's suit to divorce Queen Catherine of Aragon in 1529, which led to its own closure at the Dissolution of the Monasteries nine years later. Like Southwark, Blackfriars was resurgent through reinvention and adaptation to political circumstance; also like Southwark, it was razed by conflagration, in the Great Fire of London of 1666, but built anew rather than reconstructed.

For the purposes of exploring the new streets and ancient alleyways of Southwark and Blackfriars to uncover their secret, disparate and twinned histories, the boundaries of the Priory and its environs form a compact and coherent entity, but the modern-day expanse of the Metropolitan Borough of Southwark is too vast to cover in a single volume. The tours that follow therefore take place within the medieval 'burh', corresponding with its overseeing manors – the Great Liberty, the Gildable, the King's or Queen's Manor, the Clink Liberty, and the Manor of Paris Garden – irregularly bounded by Lambeth to the west, Newington to the south, and the eastern end of Bermondsey. It is very personal territory, the lure which drew me across the Atlantic as a post-graduate studying the theatre of Shakespeare many years ago, and drawing me back to enjoy its particular magic wherever I have lived in London ever since.

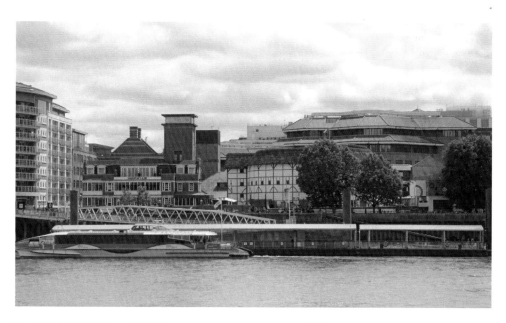

Bankside's Globe, from Blackfriars.

1. Historic Churches and Religious Houses

Tradition credits St Swithin, Bishop of Winchester between 852 and 862, as the founder of the first religious house in Southwark, but its specific location is unknown. The site of the present-day cathedral – on the western side of Borough High Street, directly south of London Bridge – is firmly associated with a religious house from 1106, when the Order of Regular or Austin Canons was founded, or refounded depending on one's point of view, by William Pont de l'Arche and William Dauncey. In his *Survey of London*, first published in 1598, John Stow relates a romantic version of the history of 'St. Mary over the Rie':

> St. Mary over the Rie, or Overie, that is over the water. This church, or some other in place thereof, was of old time, long before the Conquest, a house of sisters, founded by a maiden named Mary; unto the which house and sisters she left (as was left to her by her parents) the oversight and profits of a cross ferry, or traverse ferry over the Thames, there kept before that any bridge was built. This house of sisters was after by Swithen, a noble lady, converted into a college of priests, who in place of the ferry built a bridge of timber ... and then in the year 1106 was this church again founded for canons regulars.

'The Legend of Mary Overie' is still celebrated by a plaque to the west of the cathedral, in front of the replica of the *Golden Hinde* at Bankside.

Only fragments of its Norman fabric survived the Great Fire of 1212, with the rebuilding carrying on into the first quarter of the fourteenth century; renovation was required following another blaze during the late 1300s, and further alterations made during the reigns of King Richard II and King Henry IV, when Stow credits the poet John Gower with having been

> an especial benefactor to that work, and was there buried on the north side of the said church, in the chapel of St. John, where he founded a chantry: he lieth under a tomb of stone, with his image, also of stone, over him: the hair of his head, auburn, long to his shoulders, but curling up, and a small forked beard; on his head a chaplet, like a coronet of four roses; a habit of purple, damasked down to his feet; a collar of esses gold about his neck; under his head the likeness of three books, which he compiled.

This tomb may be visited today. William Shakespeare's brother Edmund was also buried there, in an unmarked grave, on 31 December 1607. A commemorative paving stone was later placed in the choir.

When the Priory burned down in 1212, the canons founded a hospital nearby, where they could worship until it was rebuilt. This was relocated with the consent of the Bishop of Winchester in 1228, to a site which was deemed more wholesome, and dedicated

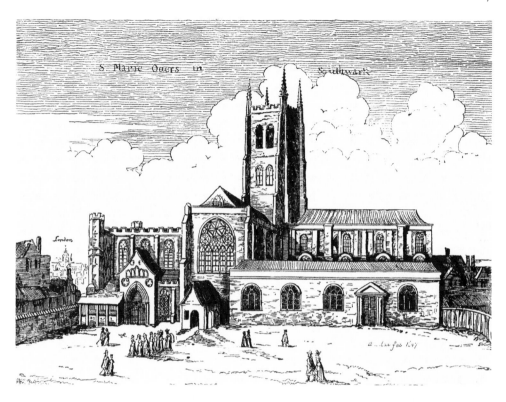

Above: St Mary Overy (from an etching by Hollar, 1647).

Right: The Old Operating Theatre and Herb Garret.

to St Thomas – initially St Thomas Becket, rededicated to Thomas the Apostle after the Reformation, when the Becket cult was abolished. As a separate building located behind the original hospital on the north side of St Thomas Street, east of Borough High Street, it was erected for the hospital's use, but made a parish church to answer the needs of the district's growing population, with a chapel for patients built within the hospital itself. It was rebuilt in 1703 and made redundant in 1899; its parish amalgamated with St Saviour's, which became the Diocese of Southwark in 1905, when the collegiate parish church was designated a cathedral, using St Thomas' as its chapter house for a time. It is best known today for housing the Old Operating Theatre and Herb Garret Medical Museum.

When the Priory was surrendered to King Henry VIII on 27 October 1539, it was valued at £624, 6 shillings and 6 pence yearly. In his *New and Accurate History and Survey of London*, published in 1766, John Entick noted that

> The vestry is select, consisting of 30 principal inhabitants; and, as this parish is divided into two liberties, *viz.* the *Borough* and the *Clink*, the officers stand thus; 6 church-wardens, chose out of the vestry; 8 overseers and collectors for the poor; 3 constables; 3 headboroughs; 4 scavengers; 23 inquest-men for the *Clink* liberty; and 6 constables and 5 scavengers for the *Borough* liberty.

Further revenue was generated after the Dissolution, with a 'parcell of the churche' leased as a bakehouse, and at one point housing pigsties.

DID YOU KNOW THAT...?

A 'Scavenger' was an elected officer responsible for keeping the streets clean, while a 'Head-borough' enforced the law in a subordinate position to the constable. 'Ale-conners' were sworn to test beer and ale to ensure that it was good, wholesome, and sold at a fair price for the full legal measure.

Before the 'Great Fire of Suthwark', the nunnery and canonical buildings associated with the Priory are thought to have stood on its south side in what came to be known as Montague Close, which takes its name from the nobleman whose house there had formerly been the Prior's lodgings. Tradition has it that the Gunpowder Plot was discovered through the misdelivery of a letter meant for Lord Montague to Lord Monteagle in the close, though this anecdote was later dismissed as a confusion of similar names. Montague was certainly sent to the Tower for his suspected involvement on 15 November 1605, but was released in August 1606 on payment of £200. By his own admission, Guy Fawkes – whom he described as 'the bluddy executioner of that woefull tragedie' – had been his servant for four months some years before, but no evidence to support his own participation in the plot has been discovered.

Montague Chambers, Montague Close.

During the London Bridge and Borough Market terror attacks of 3 June 2017, Southwark Cathedral was damaged by a controlled explosion carried out by police and closed for forensic examination; outside its offices, Montague Chambers in Montague Close, a young Australian nurse working at Guy's Hospital was killed while trying to save others. When the cathedral reopened on 11 June, a group of British Muslims handed out 3,000 roses to passers-by in the neighbourhood, as a tangible symbol that they were 'not going to let London Bridge, or any bridge, fall down'.

During the thirteenth century, the ground surrounding the Priory was wet and low-lying, consisting largely of meadow and pasture land, but the ease of access to Westminster and the City offered by London Bridge enticed a number of ecclesiastic worthies to build or buy substantial lodgings and inns there, primarily in and around today's Borough High Street. Directly behind the Priory, on its western side, as may be seen in Wenceslaus Hollar's engraving below, stood the Bishop of Winchester's House, also known as Winchester Palace, erected by the then bishop, William Giffard, *c.* 1107 – Giffard is also credited with building the nave of the Norman church founded the previous year. Stow's *Survey* reports that its plot belonged to 'the prior of Bermondsey, as appeareth by a writ directed unto the barons of the Exchequer, in the year 1366 ... for eight pounds, due to the monks of Bermondsey for the bishop of Winchester's lodging in Southwark. This is a very fair house, well repaired, and hath a large wharf and landing-place, called the bishop of Winchester's stairs'.

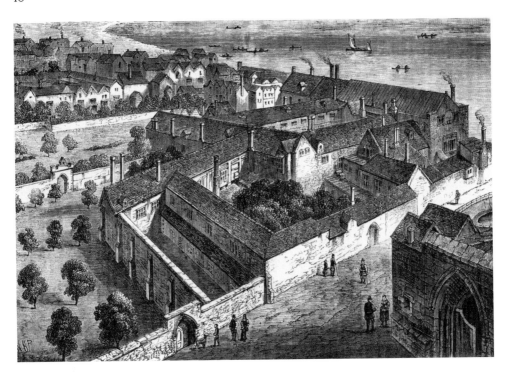

Winchester House (from a View by Hollar, 1660).

Southwark had been the largest manor in the Diocese of Winchester, whose bishop traditionally acted as the Royal Treasurer, fulfilling the role of today's Chancellor of the Exchequer, attending Parliament with fellow ecclesiastic dignitaries, consulting with the King at Court, and entertaining royal visitors at his palace; Cardinal Henry Beaufort, Bishop of Winchester in 1424, was host to King James I of Scotland there on his marriage to Joan Beaufort, the bishop's niece. The Manor of Southwark, also known as the Liberty of Winchester, was nicknamed the Liberty of the Clink *c.* 1530, by association with the infamous prison which became synonymous with the word prison itself. It was sold *c.* 1149 by the Priory of Bermondsey to the Bishop of Winchester Henry of Blois, younger brother of King Stephen, who was afterward granted the power to receive rents from brothels and license prostitutes, dubbed 'Winchester Geese', by King Henry II in 1161. It is believed to have been William of Wykeham, Bishop of Winchester between 1367 and 1398, who enlarged the hall and installed the rose window.

Stow remarks that 'Adjoining to this, on the south side the roof, is the bishop of Rochester's inn or lodging, by whom first erected I do not now remember me to have read; but well I wot the same of long time hath not been frequented by any bishop, and lieth ruinous for any lack of reparations. The abbot of Maverley had a house there.' Not long after, during the seventeenth century, the palace likewise ceased to be a bishop's lodging, and was divided into warehouses and tenements, finally destroyed by fire in 1814, with only the west gable of Wykeham's Great Hall and the rose window surviving today.

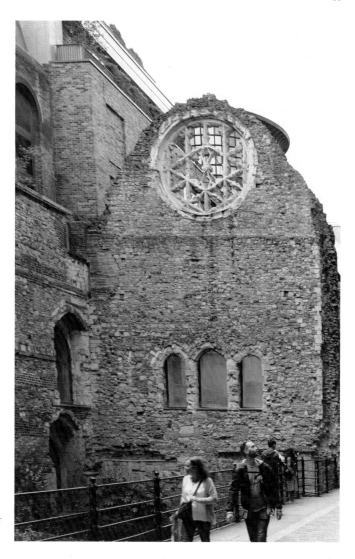

Remains of the Great Hall of Winchester Palace.

During the early thirteenth century, Bishop of Winchester Peter des Roches erected a small church dedicated to St Mary Magdalene against the wall of the Priory church to serve the needs of resident laymen, while the Parish Church of St Margaret, situated on the west side of what is now Borough High Street at its junction with Southwark Street, served most of the northern part of Southwark throughout the medieval era, having been granted to the Priory by King Henry I. An Act of Parliament dating to 1541 designated that the Priory Church of St Mary Overy become the Parish Church of St Saviour's, which subsumed the united parish of St Margaret and St Mary, with the former Parish Church converted into a sessions house. In his *Survey*, John Stow reports that 'A part of this Parish Church of St. Margaret is now a court, wherein the assizes and sessions be kept, and the court of admiralty is also there kept. One other part of the same church is now a prison, called the Compter in Southwarke.'

DID YOU KNOW THAT...?

Following the unsuccessful 'Holding of the Bridge of London' on 5–6 July 1450, the Cade Rebellion was defused on the 8th inside the Church of St Margaret, where the Archbishop of Canterbury offered Jack Cade free pardons signed by the Lord Chancellor if he and his followers would peacefully disperse, though these were swiftly revoked. After he was drawn and quartered, Cade's head was impaled on London Bridge.

The church fabric was destroyed in the Great Fire of Southwark of 1676 and rebuilt as a town hall standing in a small colonnade, where, according to Entick's 1766 *Survey*, 'the steward for the city of London holds a court of record every Monday, for all debts, damages, and trespasses within his limits'. The hall was demolished in 1791; today's island site on Borough High Street is occupied by the Slug and Lettuce pub and HSBC bank.

Turning westward to the Manor of Paris Garden, Christ Church was founded in Bennet Street by the charitable legacy of Mr John Marshal of the Borough, Gent., whose will of 1627 additionally endowed his intended new church and convenient churchyard in the parish of St Saviour with £60 yearly towards its maintenance. However, no action was taken by Marshal's trustees until 1663, when an inquisition was held under a Commission

St Margaret's Church site, Borough High Street.

of Charitable Uses, and the Lord of the Manor, William Angell, offered to supply the necessary land provided the church be built in Paris Garden. The manor was made into a parish separate from St Saviour's by an Act of Parliament in 1670, and Christ Church was at last consecrated on 17 December 1671, though the steeple and spire were not added until 1695. In 1719, John Aubrey recorded that

> The Roof is supported by *Tuscan* Pillars, and the Nave is wainscoted round about six Foot and a half high with Deal, and pewed partly with that, and partly with Oak. ... The Chancel is four Steps higher than the Nave of the Church, and at the East End is a fair Altar-Piece finished in 1696, where are the *Decalogue, Lord's Prayer,* and *Creed,* in Gold Letters on a blue Ground.

It was demolished due to decay caused by its marshy site, and rebuilt at the parish's expense between 1738 and 1741. This second building was gutted by fire during incendiary bombing in April 1941, with the present church built on its site in 1958, on what is now the western side of Blackfriars Road.

A twelfth-century copy of Pope Constantine's letter granting privileges to the monastery at 'Vermundesei' dates the first religious house at Bermondsey to before AD 715, after which the historical record falls silent until 1081, when the Priory dedicated to St Saviour was founded with royal licence by Alwin Childe, Citizen of London – described as a 'new and handsome church' in the Domesday Survey of 1086. According to Stow,

> Peter, Richard, Obstert, and Umbalde, monks de Charitate, came unto Bermondsey, in the year 1089, and Peter was made first prior there, by appointment of the prior of the house, called Charity in France, by which means this priory of Bermondsey (being a cell to that in France) was accounted a priory of Aliens.

After Alwin Childe's death in 1094, William Rufus granted his 'Manor of Bermond's Eye', with its appurtenances, to the Cluniac monks, for whom a great new church was built. In 1371, when 'Priories of Aliens' were seized by King Edward III throughout England, an Englishman named Richard Denton was made Prior of Bermondsey by Letters Patent, with the advowson of churches saved to the king.

As Entick explains,

> The manor of *Bermond's-eye* was an ancient demesne of the crown, and all the lands and tenements belonging to it ... were impleadable in the court of this manor only, and not at the common-law: though this house was no other than a cell to the priory of *Charity* in *France*: and therefore accounted a priory alien till the year 1380, when *Richard* II. in consideration of 200 marks paid into his exchequer, made it denizen [i.e. granted to aliens the freedom of the English]; when it was also made an abbey, and [John] *Attleborough* became the first abbot of *Bermondsey.*

It became independent of La Charité and Cluny in 1390. When the Abbey was surrendered to King Henry VIII in 1539, it was valued at £474, 14 shillings and 4 pence

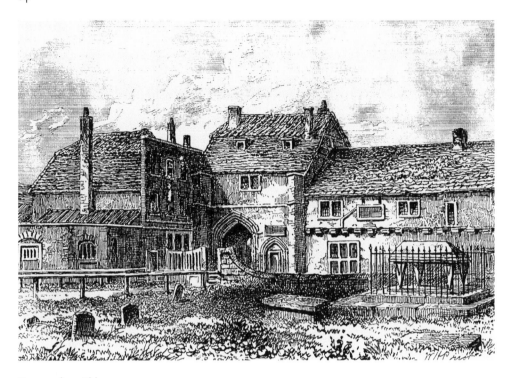

Bermondsey Abbey, 1790.

halfpenny yearly. The Crown granted the property to Sir Robert Southwell, who sold its buildings to Sir Thomas Pope. Pope demolished some and incorporated others when erecting a substantial house of stone and timber, which he sold back to Southwell prior to dying of the plague in 1558. It was the residence of Thomas Radclyffe, 3rd Earl of Sussex, in 1570, when he entertained Queen Elizabeth I there, and was still held by the Earls of Sussex in 1598. Its remains were visible in 1766 'in the gate-way that leads into a court at the south end' of the churchyard of the Parish Church of St Mary Magdalen.

The original Church of St Mary Magdalen had been built by the Priors of Bermondsey by 1290, when its dedication was first recorded, to serve their tenants and the lay workers at the Abbey. Its ancient parish was in the Diocese of Winchester until 1877, then Rochester until 1905, when it was incorporated into the newly created Diocese of Southwark. Its fabric, of unknown design, was demolished in 1680, with rebuilding on part of the Abbey's foundations completed c. 1690. Entick described it in 1766 as 'a plain structure, 76 feet long, 61 feet broad, and 30 feet high to the roof, and 87 feet to the top of the steeple. The walls are brick, covered with stucco, and the door-cases and arched windows are cased with stone. ... Here is an organ and eight bells'. The organ known to Entick was installed in 1751, and replaced in 1851, with the original reused at the Church of St Peter and St Paul in Heytesbury, Wiltshire, in 1854. The church's tower and west end were given a Gothic makeover in 1830, when the medieval west window was also restored, the interior redecorated in the Gothic Revival style in 1852. Having survived enemy action during the Second World War, the interior of its west end sustained fire

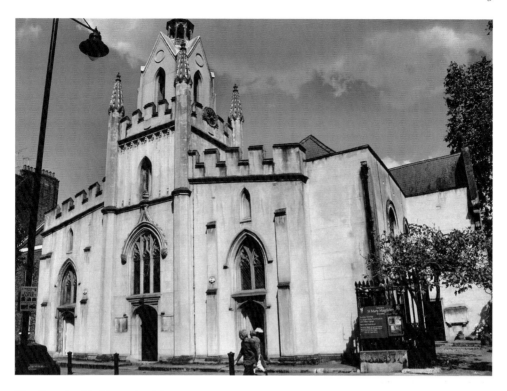

The Church of St Mary Magdalen.

damage in 1971 but was refurbished, and St Mary Magdalen stands today as the oldest building in the district.

Now part of the amalgamated 'Parish of St Mary Magdalen with St Olave, St John and St Luke, Bermondsey', Horsleydown had originally been a grazing ground for horses, its name a corruption of 'Horse-down'. Its church, dedicated to St John the Evangelist, was built by an Act of Parliament between 1726 and 1733, to a design by Nicholas Hawksmoor and John James. John Entick described its body as 'enlightened by two ranges of windows, with a *Venetian* in the center. The tower rises square, with a balustrade on the top: from whence rises a spire, which is very properly diminished, and well wrought. It is situated near the lower end of *Fair-street*', south of its junction with Tooley Street, on the western side of the present-day Tower Bridge Road. The fabric was severely damaged during the Blitz on 20 September 1940; although a portion of the church remained in use, the parish was united with St Olave's in 1947. St John's was closed in 1968, its site rebuilt and now occupied by the London City Mission.

Perhaps best known as 'Little Dorrit's church' from its association with the novel by Charles Dickens in which many scenes are set in its surrounds, the twelfth-century Church of St George belonged to Bermondsey Abbey, whose annals record that it was a gift of Thomas Ardern and his son Thomas in 1122, which also included 'land of London Bridge returning five solidos' (shillings). The Norman structure was superseded by a church with a bell tower at the end of the fourteenth century – thought to be the church pictured in William Hogarth's Southwark Fair engraving of 1733, soon before it was demolished.

DID YOU KNOW THAT...?

The Aldermen of London welcomed King Henry V on his triumphal return from the Battle of Agincourt – the first time the red cross was borne as the English standard – on the steps of St George's in 1415, the 'Agincourt Song' having been commissioned for the revels. It was in this same year that St George became the patron saint of England.

It was rebuilt, and reopened in 1736 in its original location toward the bottom of Borough High Street on its eastern side, now an island site due to the redevelopment of adjoining streets. A contemporary description of its interior is provided by Entick's *Survey*:

> To this church there is an ascent by a high flight of steps, with an *Ionic* door-case under a circular pediment, that reaches the height of the roof, ornamented with cherubims, and adorned with a balustrade and vases in front. The tower rises from hence plain. On the corners are placed vases; and from hence are raised a series of *Ionic* columns, supporting the base of the spire.

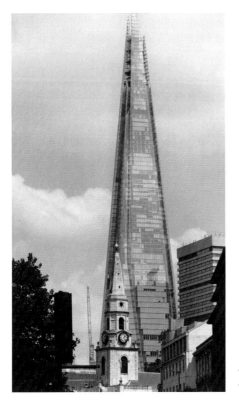

The Church of St George the Martyr, with The Shard.

St George the Martyr suffered severe damage during the Second World War, but its eighteenth-century fabric was fully restored, and its south wall and foundations strengthened in 1938. The east window, destroyed in 1942, was replaced with panels which include a design by Marion Grant picturing Little Dorrit, who kneels holding a poke bonnet. Today, its elegant spire is shown to advantage, rather than diminished, set against the 'cloud-capped tower' that is The Shard.

With an enduring reputation as a safe haven for outcasts, Southwark inevitably attracted disenfranchised elements of society who settled in particular districts within the borough, creating diverse congregations with distinct needs. John Stow's *Survey* notes that 'On the bank of the river of Thames, is the parish-church of St. Olave, a fair and meet large church, but a far larger parish [than St Thomas'], especially of aliens or strangers, and poor people.' Its Saxon timber building predated the Conquest of 1066, its name honouring Olav Haraldsson, King of Norway, an ally of King Ethelred the Unready during the Danish invasion. The Norman stone church that replaced it on the north side of St Olave's – now Tooley (a corruption of t'olous, i.e. Olav's) – Street, east of London Bridge, collapsed in 1736 and was rebuilt between 1737 and 1739 at a cost of £5,000, charged on the houses and lands within the parish at the rate of sixpence on the pound. John Entick described it as 'built of brick, with rustic quoins at the corners; and a tower of three stages, at the top of which is a plain, substantial balustrade. The whole

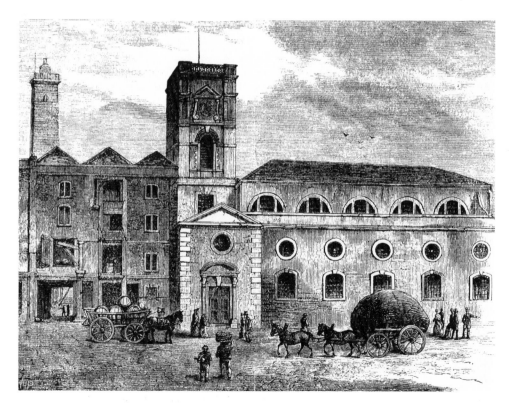

St Olave's Church, 1820.

has an air of plainness and simplicity. ... The whole parish is computed to contain 3000 houses'. St Olave's was severely damaged by fire in 1843 and fully restored, but due to Docklands' industrial expansion and corresponding decrease in resident population, it was made redundant in 1926 and demolished; the tower's capping turret was conveyed to Southwark's Tanner Street Park in 1928, and transformed into a drinking fountain. Its name lives on in St Olaf House – part of London Bridge Hospital, which opened in 1986 – built on the church's site.

The sixteenth and seventeenth centuries saw an influx of refugees from Flanders and Holland, and Southwark became a stronghold of nonconformity. Numerous meeting houses were established on either side of London Bridge, with Presbyterians congregating in St Thomas Street to the east, Independents based to the west in Deadman's Place, Bankside, from at least 1621 (now under Southwark Bridge Village Car Park), and the Baptists in nearby Zoar Street, with an 'Anabaptist-dipping-place' recorded in 1766.

Turning southward, the Methodist and Congregational Surrey Chapel, familiarly known as the 'Octagon Chapel', was built by the Revd Rowland Hill and his brother Sir Richard Hill, Bart, in 1782 on the north-east corner of Blackfriars Road and Union Street, a lease of the ground assigned in trust for the 'Protestant Dissenters' of Lady Huntingdon's Connexion (a small coalition of Evangelical churches). The Revd Hill is said to have observed that

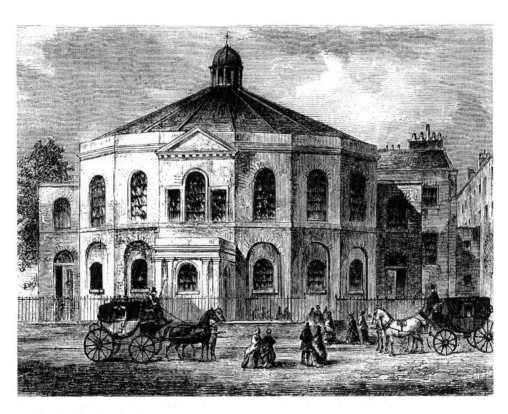

Rowland Hill's Chapel, 1814.

its circular shape 'prevented the Devil from hiding in any corners'. An early advocate of vaccination, who 'himself performed the operation on many thousands of people', he must have been as charismatic as he was eccentric, since he regularly drew in substantial congregations before his death in 1833. The conductor, composer, and arranger Benjamin Jacob served as the chapel's organist between 1794 and 1825, additionally attracting large audiences at a time when the building also functioned as a venue for musical events – perhaps in answer to the Revd Hill's query 'Why should the Devil have all the good tunes?' – and meetings of charities and associations, including the London Missionary Society. Its congregation having moved to the new Christ Church on Westminster Bridge Road in 1876, the chapel was deconsecrated in 1881, with the building partially demolished and refitted for use as a factory, before its purchase by former British Lightweight champion Dick Burge in 1910, who transformed it into a boxing arena called 'The Ring'. It remained a popular venue through to the 1930s, but was severely damaged by bombing during the Second World War. It was finally demolished during the 1950s.

A second 'Ring', however, survives in the form of a public house at the south-west corner of Blackfriars Road and The Cut, opposite the arena from which it took its name soon after it was launched. Originally called the Railway Tavern, the pub was built *c.* 1869 and christened in honour of the recent arrival of the London, Chatham & Dover Railway line and goods depot during the mid-1860s.

The late eighteenth-century house, which once stood opposite the Surrey Chapel at the south-east corner of Blackfriars Road and Union Street (destroyed in 1940–41), was in the occupation of a succession of ironmongers until 1931; its trademark sign hung outside picturing a brass dog and pot. Recalling his days as a poor child working at a blacking factory in Charing Cross while his father was imprisoned for debt in Southwark's Marshalsea Prison, Charles Dickens later remembered the route to his lodgings: 'My usual way home was over Blackfriars-bridge, and down that turning in the Blackfriars-road which has Rowland Hill's chapel on one side, and the likeness of a golden dog licking a golden pot over a shop door on the other.'

The sign Dickens remembered was sold in 1931 and may now be seen at the Cuming Museum in Walworth Road, but a replica was commissioned by Southwark Council for reinstallation in March 2013, after a year of bicentennial celebrations commemorating Dickens's birth. The 2 June 1860 edition of his journal *All the Year Round* includes an article titled 'One Eye-Witness Among the Buildings', which argues

> Let us have no restorations. Mend, if you will, repair as much as you like, but never attempt to return to the past. No more classics, no more mediævalisms, no more bran-new gothic architecture, no more illumination. These things have all been done, done gloriously and perfectly, done once for all. It is wise to do that which you can do better than it has ever been done before. ... This is an age of glass and iron, why is there no church constructed of those materials?

I think he would have approved of Southwark's new 'glass cathedrals' – The Shard and Palestra House – the office block which now occupies the sites of the Ironmongery and Surrey Chapel, with the *Dog and Pot* sculpture set beside it.

Palestra.

2. The Black Friars

The founding of the Dominican Order of Preachers, familiarly known as the Black Friars, was approved by Papal Bull on 22 December 1216, first appearing in England in Oxford in 1221, and shortly after in London in 'Old borne' (Holborn), where they remained for fifty-five years. In 1276, the Lord Mayor and Barons of London granted land near Baynard's Castle on the riverbank opposite Southwark's Bankside to Robert Kilwarby, Archbishop of Canterbury, himself formerly a Dominican monk. Kilwarby built a large church and monastery on this land for the Black Friars, with King Edward I and his Queen, Eleanor of Castile, among its greatest benefactors. John Stow's 1598 *Survey of London* describes the building as a

> large church, and richly furnished with ornaments, wherein divers parliaments, and other great meetings, hath been holden ... In the year 1524, the 15th of April, a parliament was begun at the Black Friers ... This parliament was adjourned to Westminster amongst the black monks, and ended in the king's palace there, the 14th of August, at nine of the clock in the night, and was therefore called the Black parliament.

DID YOU KNOW THAT...?

A description of Blackfriars Priory and its architectural details is included in *Pierce the Ploughman's Crede*, written c. 1394 (lines 157–218).

After the Dissolution of the Monasteries, the Friary was confiscated by the Crown; as the King's property, it was therefore outside the jurisdiction of the Lord Mayor and Aldermen of London, despite being situated within the city's walls, making it a desirable location for the affluent and aristocratic to take up residence when its component parts were sold and the area redeveloped. Shakespearean scholar Joseph Quincy Adams published his recreated ground plan of the monastery in 1917, having meticulously compiled his research from the original historical record, to which I have added Adams' identification of the untitled monastic buildings, and present-day street names in their approximate positions, to guide a tour of the site as it appeared after its Reformation makeover.

The unmarked north-western block above the preaching nave was the church porch, later known as the Square Tower, which incorporated a small chapel; a 'shop, commonly called the Round house or Corner shop' was subsequently built at its western end.

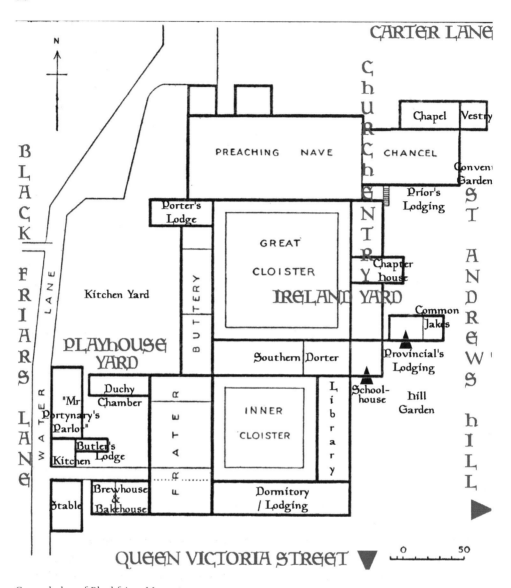

Ground plan of Blackfriars Monastery.

The slightly wider block on its eastern side was originally the Anchoress' House. It was occupied by Sir Morisse Griffith before its grant to the Master of the Revels, Sir Thomas Cawarden, who leased it to Thomas Phillipps, Clerk of the Revels, with Phillipps also allowed the use of part of what had been the porch chapel as a stable.

Following its reincarnation as Richard Farrant's First Blackfriars Theatre, the site of the Buttery was acquired by the Worshipful Society of Apothecaries, founded in 1617 by grant of a royal charter from King James VI and I, which made it independent of the Grocers' Company (founded in 1345). After the building, purchased in 1632, fell victim to the Great Fire of London in 1666, construction of a new hall on the same site was completed in 1672,

Apothecaries' Hall, from the Courtyard.

with substantial restoration undertaken during the 1780s, which included the addition of a stucco facing into the courtyard and external building works, its appearance little altered since that time.

The top floor of the Frater, south of the Buttery, was a single room, known both as the Upper Frater and the Parliament Chamber, from its association as a meeting place for the English parliament during the reign of King Henry VIII. It was accessed via a winding stairway leading out of the yard toward the north and was an independent unit, separate from the building's other sectors. The storey below was divided into three units: the Hall, Parlor, and Infirmary, also known as the Fermery, which is described as being around one third of the size of the Parliament Chamber, and lying at the western end of the Inner Cloister. Due to a sudden drop in ground level, where it sloped to the river, this portion of the Frater was four storeys high, comprised of a 'room beneath the Fermery' (a cellar), the Infirmary proper, a 'room above the same', and the south end of the Parliament Chamber 'over the room above the Fermery'.

The two unmarked vertical rectangles on the east side of the Great Cloister, north and south of the Chapter House, represent the East Dorter (dormitory); it abutted the Belfry and Chancel at its northern border, while its southern end held an entry leading into the Great Cloister, which itself lay south of the nave. The cloister was demolished and

Printing House
Square and *The Times*
office, 1870.

transformed into a 'great square garden', which was redeveloped into Printing House Square during the mid-seventeenth century, taking its name from the Offices of the King's Printers, located there from the time of the Restoration, and of the first *London Gazette*, also established during the reign of King Charles II. The king's printing house was relocated to New Street near Fleet Street in February 1770, but the square retained its title and became the original home of *The Times* newspaper (now based in Wapping), whose first edition was published on 1 January 1788, its edition of 29 November 1814 being the first ever to be machine-printed.

East of the Frater, the Stable, Brewhouse and Bakehouse were granted, along with the Infirmary, to Lady Mary Kingston, who served the first four wives of King Henry VIII. The library running along the eastern side of the Inner Cloister was comprised of 'the Great or Upper Library', the 'Under Library', and 'also two chambers and a cellar underneath the library which sometime was the Under Library adjoined to the Hill Garden'. A parcel of this three-storey property was granted with the Hill Garden, Schoolhouse, and Provincial's Lodging, to Lady Anne Grey, step-daughter of Lady Kingston.

The Southern Dorter, running above the Inner Cloister and library, is thought to have been the monastery's chief manse, and became Sir Thomas Cawarden's 'Great Mansion' following its occupation by Lady Kingston. At her death, this property was inherited by her son, Henry Jerningham, who would become a leading supporter of Lady Mary Tudor's succession to the throne – it was next occupied by Anthony Kempe, then by the

Lord Chamberlain, Lord Hunsdon, who was patron to Richard Burbage's and William Shakespeare's company of players. Burbage himself bought Mr Portynary's Parlor to the south-west in 1610.

The dormitory running below the Inner Cloister and library had already been rented out by the Friary as autonomous lodgings many years prior to the Dissolution of the Monasteries. In 1536, it was leased to Sir William Kingston, Constable of the Tower of London – charged with the keeping of Queen Anne Boleyn there in May of the same year – his third wife Lady Mary Kingston, and stepson Henry Jerningham, at which time access was gained through 'a way to the water-side, between the garden of my Lady Paycokes of the west part, and the garden of Richard Trice of the east part'. The Kingstons also had the use of the two chambers and cellar beneath the Under Library, which adjoined it, and procured the larger section of the library and Inner Cloister, with its adjacent buildings, subsequently acquired by Lord Hunsdon.

Among the eminent persons interred at Blackfriars before its Reformation facelift were John Tiptoft, 1st Earl of Worcester, and James Tuchet, 7th Baron Audley, respectively beheaded in 1470 and 1497 for their parts in the Wars of the Roses and the Cornish Rebellion; Sir Thomas Parr, whose daughter Katherine (later to become King Henry VIII's surviving Queen) was born at the family's town house in Blackfriars; and the heart of Queen Eleanor of Castile, co-founder of the Friary with her husband, King Edward I. The tombs, however, were destroyed in 1538.

Following the Dissolution of the Monasteries, the old Priory church initially served as the local parish church from 1544 until its demolition in 1550, to make way for

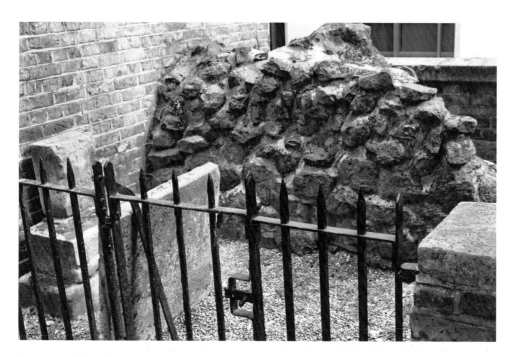

Remains of Blackfriars Priory, Ireland Yard.

tennis courts. Historical documents record that John Bailies was buried 'in St. Anne's Chapel' in 1502, and Roger Watley 'in the Chapel of St. Anne within and adjoining the church' in 1520, suggesting that the chapel at the church's north-eastern end was called St Anne's, and was where the newly reformed Protestant congregation worshipped. Stow's *Survey of London* reports that

> There is a parish of St. Anne within the precinct of the Black Friers, which was pulled down with the Friers' church, by Sir Thomas Carden [*sic.*, Cawarden]; but in the reign of Queen Mary, he being forced to find a church to the inhabitants, allowed them a lodging chamber above a stair, which since that time, to wit, in the year 1597, fell down, and was again by collection therefore made, new built and enlarged in the same year, and was dedicated on the 11th of December.

The site on which the substantially larger 'Church or Chapel of St. Ann, within the Precinct of Blackfriars' was built, now known as Ireland Yard and originally part of the Priory's Provincial's Hall, included an additional piece of ground on the western side, which the parishioners bought from Sir George More, soon to be Chamberlain of the Receipt in the Exchequer and father-in-law to the metaphysical poet John Donne.

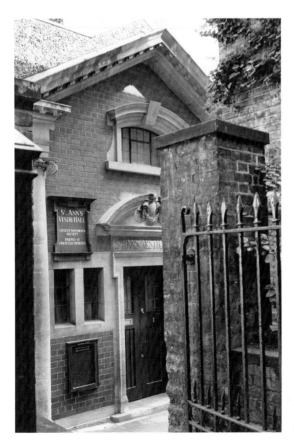

St Ann's Vestry Hall, Church Entry.

Supplementary ground was again purchased in 1613, and an aisle built, with a burial vault underneath, consecrated on 29 July 1617. Following the razing of Blackfriars in the Great Fire of London, St Ann's parish was amalgamated with that of St Andrew-by-the-Wardrobe, and the church was not rebuilt. Its site, however, now known as St Ann's Churchyard, continued to be used for interments, as did its existing burial ground, known as Church Entry, situated atop part of the Friary church nave. A plaque inside the entry gate notes that 'The name "Church Entry" indicates the usual passage between the nave and chancel passing north and south beneath the steeple.' Both were closed to burials in 1849 and are now public gardens, maintained by the Corporation of London since 1964. Each is raised and largely paved, containing a number of tombstones and flat grave slabs, trees and shrubs, making the pair a twin oasis of tranquillity, evoking the contemplative atmosphere of a monastery whose physical essence has been lost.

On the opposite side of the gate leading into the Church Entry garden stands St Ann's Vestry Hall, whose baroque-style façade calls to mind the simple elegance of a Christopher Wren church but was in fact erected in 1923. It provides offices for the 'Friends of Friendless Churches', founded in 1957, whose mandate is to campaign for, rescue, and repair redundant historic churches in England and Wales, which are under threat of demolition and decay, preserving them for their local communities' continued enjoyment.

Walking a few steps east past Church Entry, then south to the bottom of St Andrew's Hill, brings us to the site of the first Baynard's Castle, named for the Norman nobleman who built it on the northern bank of the Thames after the Conquest, on the southern side of what is now No. 160 Queen Victoria Street. When his second successor, William Baynard, forfeited his barony through felony, King Henry I gave his property, including the honour of Baynard's Castle, to Robert of Clare and his heirs. Robert was succeeded by his son Walter Fitz-Robert, in turn succeeded by his son Robert Fitz-Walter, whose daughter Matilda the Fair became the subject of discord between King John and his barons c. 1213 when her father refused consent to the king's unlawful amorous intentions. (This is the chain of events according to the *Chronicle of Dunmow*, the more likely cause of the dispute being financial.) War ensued, with Fitz-Walter leading the Barons' Revolt; he was banished and his castle despoiled. During his absence in France, the king renewed his suit, and, when Matilda continued to resist, his messenger killed her by poisoning her boiled or 'potched' egg. Fitz-Walter swiftly regained the king's favour through his service in France, and his properties were restored, with licence given to repair Baynard's Castle. The site was sold by his grandson, also named Robert Fitz-Walter, in 1276, becoming part of the precinct of Blackfriars Priory. A second Baynard's Castle, pictured below, was built by Humphrey, Duke of Gloucester, on the riverbank 100 meters south-east of the original in 1428, in the wake of a 'great fire', which destroyed an earlier town house located there.

Following Gloucester's death in 1447, shortly after his arrest for treason, Baynard's Castle passed to the Crown, and by 1457 to Richard Plantagenet, 3rd Duke of York, who was killed three years later at the Battle of Wakefield. His eldest surviving son assumed the crown within the castle walls in 1461 as King Edward IV, and his youngest son as King Richard III in 1483.

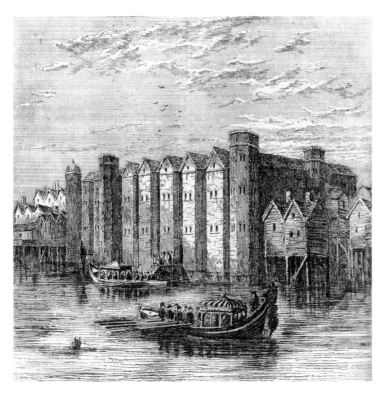

Baynard's Castle, 1790.

DID YOU KNOW THAT...?

William Shakespeare depicts the proceedings at Baynard's Castle in Act III scene vii of *King Richard III* as stage-managed by an arch manipulator whose energetic wit is on the brink of descending into peevish savagery. One of his main sources was the *History of King Richard III* by Tudor statesman Sir Thomas More, who both portrayed Richard as a witty villain and noted the correspondence between theatre and politics: 'And so they said that these matters bee kynges games, as it were stage playes, and for the more part plaied upon scaffolds.'

King Henry VII restructured it anew *c.* 1501, transforming it from fortified castle to royal mansion, and frequently lodged there in the years that followed. King Henry VIII gifted his bride-to-be Catherine of Aragon with Baynard's Castle on the day before their marriage in June 1509, and by 1551 it had come into the possession of William Herbert, who was created 1st Earl of Pembroke in the same year. On 19 July 1553, it became the assembly site for the Privy Council, who had previously backed Lady Jane Grey's succession to the Crown after the death of King Edward VI, but were now swayed by public support for Lady Mary as eldest surviving child of King Henry VIII, conferring

with Pembroke, the Earl of Shrewsbury, and Sir John Mason, before sending for the Lord Mayor and riding 'into Cheap to the cross' where trumpets were sounded and the Garter King at Arms proclaimed the Lady Mary Queen of England. The 4th Earl of Pembroke having backed the Parliamentarian cause during the Civil War, it was a Royalist occupier, the Earl of Shrewsbury, who entertained the newly restored King Charles II there on 19 June 1660, according to an entry made by Samuel Pepys in his *Diary*. Only one tower was left standing after the Great Fire of London six years later; it was eventually demolished in the nineteenth century, the site now occupied by a concrete office block, its underside protected as a Scheduled Ancient Monument.

On the north side of Queen Victoria Street, opposite, stands St Andrew-by-the-Wardrobe, founded before 1170, when it was first recorded by name. It formed part of the first Baynard's Castle during the thirteenth century, and, prior to the relocation of the Royal Wardrobe, was fittingly known as St Andrew by Castle Baynard. The medieval church was razed by the Great Fire of London and rebuilt by Sir Christopher Wren in 1695, only to be destroyed a second time during the London Blitz of the Second World War, though its baroque tower and walls survived. Its present interior and some exterior features were reconstructed from the fittings of other lost Wren churches, the pulpit, font and cover coming from St Matthew Friday Street in Cheapside, the Stuart Arms from St Olave Old Jewry, and the weathervane from St Michael Bassishaw.

Although it served the function of storehouse for royal, state and ceremonial robes, the King's Great Wardrobe was less a building than a government department; John Stow's

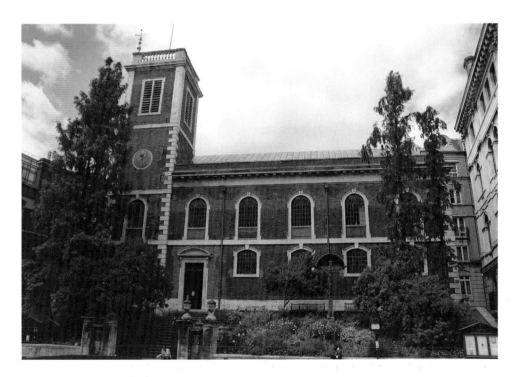

St Andrew by the Wardrobe.

Survey records that 'The secret letters and writings touching the estate of the realm were wont to be enrolled in the king's wardrobe, and not in the chancery, as appeareth by the records.' This lost building in Blackfriars – yet another casualty of the Great Fire – is commemorated by a plaque in Wardrobe Place, between St Andrew's Church and Carter Lane, returning northward up St Andrew's Hill. It had been built by Sir John Beauchamp, knight of the Garter, Constable of Dover, and Warden of the Cinque Ports, during the fourteenth century, to the great vexation of the Parson of St Andrew's, who later complained that Beauchamp had demolished several houses to construct his single domicile, thereby losing the church its accustomed tithes paid by numerous tenants. Following Beauchamp's death in 1359, his executors sold the house to King Edward III, who appointed the Great Wardrobe to be transferred there from the Tower of London in 1361, to increase space for military storage at the Tower.

Turning again to face south on St Andrew's Hill, at the north-east corner of its junction with Ireland Yard, there is a gold-framed black plaque mounted on a white-painted

The Cockpit.

building commemorating that 'On 10th March 1613 William Shakespeare Purchased Lodgings In The Blackfriars Gatehouse Located Near This Site.' Occupying the junction's south-east corner since the sixteenth century stands the Cockpit pub, so named for its history as a cockfight gambling venue, though it was rechristened The Three Castles in 1849 when cockfighting was outlawed and only changed back in 1970. The original Cockpit is said to have been converted from one of the Monastery's Gateways, with one theory ascribing Shakespeare's lodgings to this spot; the current building dates to *c.* 1865. Like The Black Friar (pub), which stands on the site of the Monastery's south-west corner, built *c.* 1875, the building's triangular profile reflects Victorian architecture sympathetically adapting to irregular shapes caused by narrow medieval alleyways.

Retracing our steps along Ireland Yard to its intersection with Playhouse Yard and bending north-west, we come to where the two Blackfriars Theatres once stood, the First Playhouse dating from 1576 to 1584, and corresponding with the Buttery on the Monastery ground plan, the Second Playhouse from 1596 to 1642, corresponding with the Frater.

From September 1554, Sir Thomas Cawarden used the Buttery, which had been converted into lodgings 'for the office of the Queen's Majestie's Revells', probably a rehearsal space for the Children of the Chapel Royal as they prepared for court performances. After his death in 1559, his property passed to Sir William More (father of Sir George), who leased the Buttery to a series of tenants, before Richard Farrant, Master of the Children of Windsor Chapel, devised a plan to emulate the financial success enjoyed by professional actors who entertained the general public, in contrast to the relative pittance he earned for court entertainments. Though his lease was not signed until 20 December 1576, Farrant took possession on 29 September, leaving ample time to prepare for Christmas entertainments. In contrast to the Burbages' open-air amphitheatre in Shoreditch, Farrant created an indoor theatre modelled on the halls at court in which his choristers were accustomed to performing, and his targeted aristocratic audiences to attending. More, who had been unaware of his new tenant's scheme, later complained that Farrant 'spoiled' the windows, suggesting that he stopped them up to maximise the effect of performing by candlelight. A stage was raised at one end of the now single-room Buttery, with benches arranged at ground level to create an auditorium, which was accessed via Water Lane. The lease contained a clause to prevent Farrant from subletting ancillary quarters 'without the especial license, consent, and agreement of the said Sir William More ... first had and obtained in writing', but Farrant rented them out regardless, and More immediately set out to void the lease. He finally regained possession in 1584, when he turned the First Blackfriars Playhouse back into lodgings, which he swiftly rented to Lord Hunsdon.

In 1596, with his lease for The Theatre's Shoreditch site set to expire the following year, James Burbage decided to create a public indoor playhouse, whose roof would shield actors and audiences alike from bad weather, most importantly the cold, thereby enabling a winter season. To this end, he bought Sir William More's Blackfriars properties, excepting the Infirmary leased to his patron Lord Hunsdon. These were comprised of the Parliament Chamber, encompassing the entire top floor of the building; the central paved 'Parlor', used as a fencing school during the 1560s through 1580s, now termed 'the Middle Rooms or Middle Stories', with two cellars underneath on its northern side; the Hall beside the Parlor to the north, which had been converted into tenements described

The Sam Wanamaker Playhouse banner.

as 'all those two lower rooms ... lying directly under part of the said seven great upper rooms'; and the three-storey Duchy Chamber building 'at the north end of the said seven great upper rooms, and at the west side thereof'.

James Burbage's plans were thwarted by the sustained litigation of his titled neighbours, including Lord Hunsdon, and he died the following year. In 1600, his son Richard was at last able to lease the Second Blackfriars Theatre to Henry Evans, manager of the Children of the Chapel, who had been among those ousted from the First Blackfriars in 1584, and whose tenure the neighbourhood did not contest due to the higher social status of boy players and their audiences. The Burbages' company, including William Shakespeare, regained the lease in 1608, from which time The King's Men were at last able to perform during the winter season at Blackfriars.

While it is generally assumed it was the Parliament Chamber that was converted to create the Second Blackfriars Theatre, I agree with the theory that it must have been the Parlor and the Hall on the basis of their physical location – legal documents repeatedly describe the playhouse as 'that great hall or room, with the rooms over the same' (the seven-room Parliament Chamber being the top storey). It had already successfully housed a 'school of fence': the 1696 deed of sale describes the Parlor as 'those roomes and lodgings with the kitchen thereunto adjoining, called the Middle Rooms or Middle Stories, late being in the tenure or occupation of Rocco Bonnetto'.

DID YOU KNOW THAT...?

Fencing Master Rocco Bonetti's boast that he could 'hit any Englishman with a thrust upon any button' is echoed in Mercutio's lampoon of Tybalt in Shakespeare's *Romeo and Juliet*: 'He fights as you sing prick-song, keeps time, distance, and proportion; rests me his minim rest, one, two, and the third in your bosom: the very butcher of a silk button, a duellist, a duellist ... ah, the immortal passado! The punto reverso! The hai!'

The Burbages would have had to remove partitions that had been erected in the Middle Rooms to restore the Parlor to its original form, adding the adjoining Hall and removing its single partition. With the Infirmary below the Parliament Chamber known to have been three storeys tall, the Parlor's ceilings would have been high enough to allow for several galleries to run along its walls, as they did in open-air theatres. The entrance being at the north end, over the 'great yard' that led to Water Lane, the stage would have been built opposite, at the south end, with chandeliers hung above to provide illumination in lieu of sunlight.

The Second Blackfriars Theatre closed – as did all playhouses – at the outbreak of the Civil War in 1642, and according to an annotated copy of Stow's *Survey*, 'The Blackfriars players's playhouse in Blackfriars, London, which had stood many years, was pulled down to the ground on Monday the 6 day of August, 1655, and tenements

Remnant of Blackfriars Theatre.

built in the room.' The entire site was lost to the Great Fire of London eleven years later, with only a portion of one black cornerstone surviving in Playhouse Yard, as pictured above.

However, its spirit lives on in the Sam Wanamaker Playhouse, built in the style of the Second Blackfriars across the river at Southwark's Bankside, which opened with John Webster's *The Duchess of Malfi* on 15 January 2014, first privately performed by The King's Men at The Blackfriars *c.* 1614, with Richard Burbage in the role of the Duchess' twin brother, Ferdinand.

Carrying on to the end of Playhouse Yard to its T-junction with Black Friars Lane and turning south, then west at the next T-junction with Queen Victoria Street, leads us to The Black Friar public house at the corner of Blackfriars Court, once the Priory's own south-west corner. Its edifice was built in 1875 and remodelled by architect H. Fuller Clarke *c.* 1905 and 1917, with mosaics and carved figures added by sculptors Frederick Callcott and Henry Poole, and grotesques by architectural sculptor and modeller Nathaniel Hitch. The spectacular Arts and Crafts interior features a stained-glass window beside the front entrance, picturing a monk in a sunlit garden, and variegated marble cladding with brass, mosaic, wood and copper reliefs. The dining room at the rear, known as the Grotto, was excavated from a railway vault between 1917 and 1921 according to Clarke's 1913 design, its construction having been delayed by the outbreak of the First World War, and one can hear the intermittent rumble of passing trains while enjoying hospitality there. Slated for demolition during the 1960s as part of a new phase of redevelopment, it was saved by a

The Grotto, west wall.

campaign led by Sir John Betjeman, and was filed by Historic England as a Grade II-listed building on 5 June 1975. The figure of the Black Friar beneath the clock on its triangular south-east corner is thought to have been added *c.* 1983.

Originally divided to reflect its patrons' social classes, the bar on the east side of the front entrance is characterised by its wooden décor, while the Saloon on the west side, leading into the Grotto, features the marble and bronze reliefs – each equally attractive to a modern eye, with plenty of cosy nooks to recuperate in after a day of rambling.

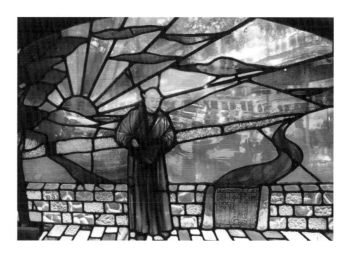

The Black Friar in his garden.

3. Famous Theatres, Then and Now

The theatrical motif of Southwark's blazon encapsulates its enduring and vibrant artistic energy: 'Supporters: On the dexter side an Elizabethan Player habited as for the role of Hamlet holding a Skull in the exterior hand and on the sinister side a Youth habited in early Fifteenth Century dress [as worn by Chaucer's Pilgrims] all proper.' Yet before it became indelibly associated with dramatic performance, Southwark's Bankside west of London Bridge had been equally famous as a sporting district, with open fields for athletics, butts for archery, and rings for animal baiting (the most popular form of amusement), and gaming. Initially, bulls and bears were tied to stakes before being pitted against bulldogs and mastiffs, to ensure the spectators' safety as they crowded round or stood on temporary platforms; with the coming of dedicated amphitheatres, the animals were released into a central arena, where the public watched from the safety of the stands. As John Stow describes the west bank in his 1598 *Survey of London*, 'there be two bear gardens, the old and new places, wherein be kept bears, bulls, and other beasts, to be baited; as also mastiffs in several kennels, nourished to bait them. These bears and other beasts are there baited in plots of ground, scaffolded about for the beholders to stand safe.' An account written by one of the attendants of the Duke of Nexara, who visited England in 1544, provides a window into what those 'other beasts' could be: 'Into the same place they brought a pony with an ape fastened on its back, and to see the animal kicking amongst the dogs, with the screams of the ape, beholding the curs hanging from the ears and neck of the pony, is very laughable.'

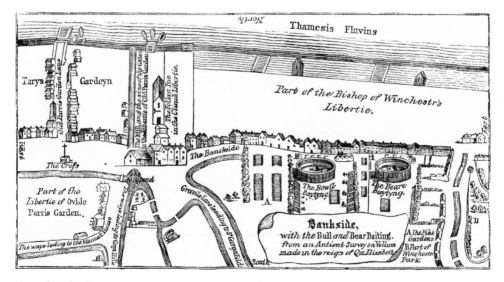

Plan of Bankside.

Though 'The Bowll Baytyng' and 'The Beare Baytyng' pictured in the mid-sixteenth century Plan of Bankside above were located in the Liberty of the Clink rather than in Paris Garden, historic association made the terms 'Bear Garden' and 'Paris Garden' interchangeable. Stow's *Annals of England* describes the tragic day in 1583 when overcrowding caused the Bear Garden to collapse:

> The same thirteenth day of January, being Sunday, about four of the clock in the afternoon, the old and underpropped scaffolds round about the Bear Garden, commonly called Paris Garden, on the south side of the river of Thamis over against the city of London, overcharged with people, fell suddenly down, whereby to the number of eight persons, men and women, were slain, and many others sore hurt and bruised to the shortening of their lives.

In its place, the New Bear Garden was erected, octagonal in shape like the new outdoor playhouses, which may themselves have imitated the old baiting rings. When it was demolished due to decay in 1613, a new playhouse, 'The Hope', was erected on its site.

Old Inns in Southwark.

Bankside had become an established seat for the theatrical profession early in the Tudor era. King Henry VIII issued a proclamation against vagabonds and players in 1545, remarking on their 'fashions commonly used at the Bank, and such like naughty places, where they much haunt'. Following the King's death two years later, the Bishop of Winchester complained that his royal dirge and mass were threatened with being overshadowed by the actors in Southwark, who planned to perform 'a solemn play, to try who shall have the most resort, they in game or I in earnest'. Increasingly, it became a home not only for plays but the players themselves, as the Liberty of the Clink, the Manor of Paris Garden, and Newington to the south were outside the jurisdiction of the City of London and its puritanical Lord Mayors, who governed the manors east of London Bridge, where performances were staged in the galleried courtyards of coaching inns and booths erected at fairs, not in dedicated playhouses.

Southwark's earliest public playhouse was constructed at roughly the same time James Burbage erected The Theatre north of the Thames in 1576, and is today considered its rival to the title of London's first playhouse, though in the humbler form of converted inn yard rather than purpose-built amphitheatre. It was located at Newington Butts, so named for the archery butts erected in its medieval practice field; its exact site and physical arrangement are unknown, though the Privy Council disparaged 'the tediousness of the way' there after crossing the river – perhaps the reason for its short lifespan. Occupied for ten days by Philip Henslowe's company between 3 and 13 June 1594 while the Rose underwent necessary repairs, an account written in 1599 refers to Newington Butts as 'only a memory'.

DID YOU KNOW THAT...?

The theatre at Newington Butts is lampooned in the comedy *A Woman is a Weathercock*, first performed *c.* 1609/10 by the Children of the Queen's Revels at the Whitefriars indoor playhouse, and written by the company's former child star Nathan Field; in Act III scene iii, Pendant counters a bad pun with 'Oh Newington conceit', suggesting that by the time of its demise Newington had become a by-word for second-rate material.

Moving the clock forward just over 400 years, a new flagship theatre is set to open at Newington Butts, providing a permanent home for the Southwark Playhouse Theatre Company after a quarter century of repeated enforced relocation. Juliet Alderdice and Tom Wilson founded the company in 1993, leasing a disused workshop at No. 62 Southwark Bridge Road and transforming it into an adaptable studio-theatre space, which quickly developed into a locally popular and professionally respected fringe venue. Compelled to leave its original premises in 2006, Southwark Playhouse redeployed to the vaults below Platform 1 at London Bridge railway station in 2007. After the station's

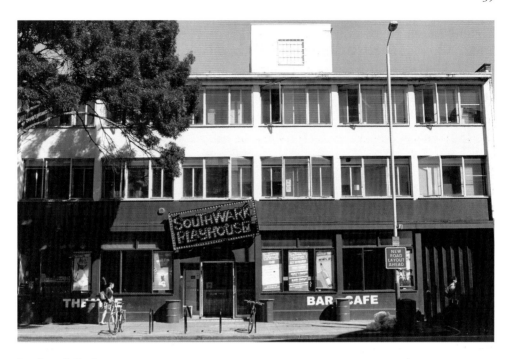

Southwark Playhouse.

planned redevelopment was announced in July 2012, the company was driven to move again in May 2013, to its present home at Nos 77–85 Newington Causeway. Thanks to an agreement made with Network Rail following a campaign backed by actors Stephen Fry and Andy Serkis, the company is set to return to its former site at London Bridge, on the corner of Tooley and Bermondsey Streets, by the end of 2019. This is projected to be a satellite venue, with two flexible 200- and 150-seat performance spaces, and a mandate to nurture work by new and emerging artists. Its main stage playhouse will open at Newington Butts, on the western side of Elephant and Castle – no longer a tedious journey – with a commitment to producing new work as well as old favourites, while increasing its support for 'free-at-source youth, community, and development programmes', aptly fulfilling Southwark's motto, 'United to Serve'.

The Rose was the first purpose-built theatre erected in Southwark. The ease of access provided by its site near the riverbank in the Liberty of the Clink quickly attracted London playgoers, shifting the centre of 'Theatreland' from the north to the southern side of the Thames. Philip Henslowe had been resident in the Clink Liberty since at least 1577, 'but a poor man' who was 'servant . . . unto one Mr. Woodward', whose assets he acquired upon marrying his widow Agnes. On 24 March 1585, he leased 'The Little Rose' at Bankside, a property that comprised of a dwelling house called 'The Rose', 'two gardens adjoining the same' containing 'void ground', and a small building, which he sublet to London grocer John Cholmley as a storehouse. Within two years he embarked on a scheme to build a theatre on part of the 'void ground' at the corner of Rose Alley and Maiden Lane, signing a deed of partnership with Cholmley on 10 January 1587.

Built in the shape of a fourteen-sided polygon, Henslowe's *Diary* records that it was made of timber, finished with lath and plaster, topped with a thatched roof and flagpole, and contained a yard, galleries, a stage, tiring house, and heavens. Despite its name, this was a Rose which did not 'smell as sweet' due to its physical location; in his *Satiromastix*, playwright Thomas Dekker quips 'Th 'ast a breath as sweet as the Rose that grows by the Bear Garden' (Act III scene iv). Henslowe had become sole proprietor by the time the playhouse was renovated for the debut of Lord Strange's Men – headed by Edward 'Ned' Alleyn – on 19 February 1592, with the company now under Henslowe's management. On 22 October, Alleyn married Joan Woodward, Henslowe's stepdaughter and only child, and the two men formed a renowned business partnership, their theatrical activity at the Rose intermittently interrupted by the closure of all London playhouses during outbreaks of plague, in the aftermath of rioting, or as a censure of political satire that cut too close to the bone. Following an order by the Privy Council on 22 June 1600, directing 'that there shall be about the city two houses, and no more, allowed to serve for the use of the common stage-plays; of the which houses, one [the Burbages' Globe] shall be in Surrey, in that place which is commonly called the Bankside, or thereabouts; and the other [Henslowe's Fortune], in Middlesex', the Rose remained vacant until Worcester's Men and Oxford's Men were 'joined by agreement together in one company', with royal assent reported to the Lord Mayor of London by the Privy Council on 31 March 1602.

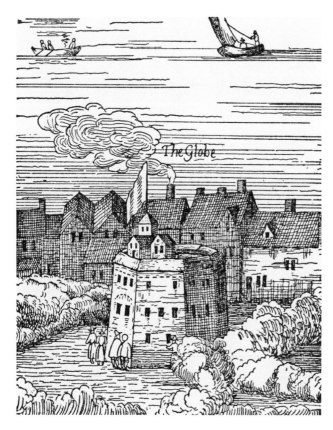

The Rose, mislabelled The Globe, 1616.

Henslowe's company left the Rose on 16 March 1603; on 19 March the Privy Council ordered the suppression of all plays, and 24 March saw the death of Queen Elizabeth I. Renamed the Queen's Men after the accession of King James VI and I in honour of his wife, Anne of Denmark, the company was performing again in May, before quitting London during an outbreak of plague, from which time no further entry mentions a play being staged at the Rose. Faced with skyrocketing rent, Henslowe decided not to renew his lease when it expired in 1605; it was taken up on 14 February 1606 by Edward Box of Bread Street, who promptly either demolished or converted the premises; the last mention of the Rose, in London's sewer records, describes it on 25 April as 'the late playhouse'.

Its remains were discovered in 1988 following the demolition of Southbridge House to make way for a new office block; I was fortunate to view the site in its early stages of excavation the following year, before the 'Save the Rose' campaign had succeeded in protecting it from redevelopment. Rose Court was subsequently erected, including a dedicated basement space for continued exhibition of the theatre's archaeology, which does not yet take in the original eastern boundary of the 'Little Rose' property; at this time of writing, Historic England is seeking to enlarge the perimeter of its existing Scheduled Monument listing to encompass it.

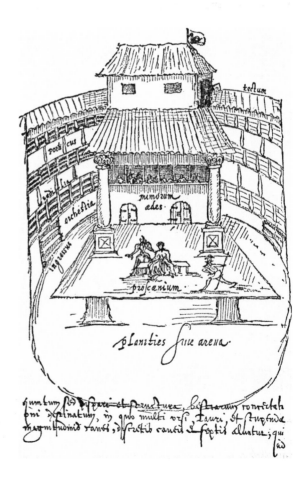

Interior of the Swan Playhouse.

In 1589, Francis Langley, Citizen and Goldsmith of London, purchased the lease of the 'lordship and manor of Paris Garden' for 1,000 years for the sum of £850, with a view to profiting from his investment. Noting the revenues generated for James Burbage and Philip Henslowe from their playhouses, he secured a licence to erect a theatre in Paris Garden by 3 November 1594, when the Lord Mayor of London voiced his opposition in a letter to the Lord High Treasurer. Happily, as the property had passed to the Crown from Bermondsey Abbey following the Dissolution of the Monasteries, it was outside the Lord Mayor's jurisdiction. The Swan was built with a dodecahedral-shaped exterior twenty-six poles (426 feet) from the riverbank in the manor's north-east sector, nearest to London Bridge, though the majority of its audience would have walked there after landing at Paris Garden Stairs or Falcon Stairs. The cleric Johannes de Witt of St Mary's in Utrecht visited London in the summer of 1596, later praising Bankside's playhouses to his friend Aernout van Buchel, who recorded de Witt's description of the Swan in his commonplace book:

> There are four amphitheatres in London [including the Theatre and the Curtain] of notable beauty, which from their diverse signs bear diverse names. ... The two more magnificent of these are situated to the southward beyond the Thames, and from the signs suspended before them are called the Rose and the Swan. ... Of all the theatres, however, the largest and the most magnificent is that one of which the sign is a swan, called in the vernacular the Swan Theatre; for it accommodates in its seats three thousand persons, and is built of a mass of flint stones ... and supported by wooden columns painted in such excellent imitation of marble that it is able to deceive even the most cunning. Since its form resembles that of a Roman work, I have made a sketch of it above.

In February 1597, eight actors from the company of Pembroke's Men severally bound themselves for the sum of £100 to hire the Swan for one year, to commence on 21 February. Langley in return committed to laying out 'for making of the said house ready, and providing of apparel fit and necessary for their playing, the sum of £300 and upwards'. Less than six months later, their performance of Thomas Nashe's satire *The Isle of Dogs* prompted a letter from the Privy Council to the Justices of Middlesex and of Surrey, dated 28 July 1597, reporting that the Queen 'hath given direction that not only no plays shall be used within London or about the city or in any public place during this time of summer, but that also those playhouses that are erected and built only for such purposes shall be plucked down'. In addition, Nashe and the principal actors in his play were to be arrested. Nashe escaped, but the leaders of Pembroke's Men, Robert Shaw and Gabriel Spencer, were imprisoned along with Ben Jonson, one of its 'inferior players' and a contributor to the script. The remaining company decamped to perform in Bristol before the month's end, with a number of its members – later joined by Shaw, Spencer, and Jonson – switching allegiance to join the Admiral's Men at Henslowe's Rose, provoking Langley to sue for breach of their bond to play exclusively at the Swan. Henslowe was granted permission to reopen the Rose on 11 October, with the Swan apparently slated for closure by the Privy Council's further order that in future only two companies should have licence to perform: the Admiral's Men at the Rose, and the Chamberlain's Men (the Burbages' and Shakespeare's company) at the Curtain. The remnants of Pembroke's

Men attempted to regroup, hiring additional actors and continuing to perform without a licence at the Swan, but were reported by the licensed companies, prompting the Privy Council to order their suppression. Langley died in 1601, and his widow sold the Manor of Paris Garden, including the Swan, to Hugh Browker, principal clerk of the Court of Common Pleas, in January 1602.

DID YOU KNOW THAT...?

The Swan was the scene of a hoax perpetrated by Richard Vennar on 6 November 1602, his one-off performance of *England's Joy*, celebrating the Queen's reign, promising a spectacular conclusion: 'with music, both with voice and instruments, she is taken up into heaven; when presently appears a throne of blessed souls; and beneath, under the stage, set forth with strange fire-works, diverse black and damned souls, wonderfully described in their several torments'. The audience paid an extortionate 'two shillings, or eighteen pence at least' for admission. Vennar promptly decamped after collecting the money, and his enraged victims vandalised the theatre.

When Philip Henslowe became manager of the Lady Elizabeth's Men on 29 August 1611, he contracted to provide them with a playhouse; having quit the Rose, he rented the Swan until new premises could be secured. Following their transfer to his new theatre in 1613, and that of his next company, Prince Charles' Men, in 1615, the Swan is next mentioned in the Account Book of the Overseers of the Poor in the Liberty of Paris Garden: 'Monday, April the 9th, 1621, received of the players £5 3s. 6d.', after which no further record links the Swan with theatrical performance. In the map of 1627 pictured below, it is labelled simply as 'the old playhouse', and it is not pictured in Hollar's View of London, suggesting that it had been demolished by 1647. An appropriate *envoi* is supplied in *Holland's Leaguer* by Nicolas Goodman, a pamphlet published in 1632 in celebration of one of Bankside's most notorious brothels; Goodman reports that its proprietress

was most taken with the report of three famous amphitheatres, which stood so near situated that her eye might take view of them from the lowest turret. One was the *Continent of the World* [the Globe], because half the year a world of beauties and brave spirits resorted unto it; the other was a building of excellent *Hope*, and though wild beasts and gladiators did most possess it ... the last which stood ... being in times past as famous as any of the other, was now fallen to decay, and like a dying *Swanne*, hanging down her head, seemed to sing her own dirge.

By the time of Henslowe's occupation of the Swan, the old Bear Garden – co-owned by himself and Jacob Meade – had suffered such severe decay that it required comprehensive

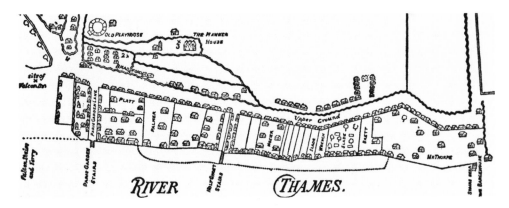

Manor of Paris Garden.

renovation; Henslowe convinced Meade of the benefits of demolishing the old ring and erecting a new building on its site, which could accommodate both the baiting of animals and the performance of plays. On 29 August 1613, the two men engaged a carpenter named Katherens to undertake the work for the sum of £360, to be completed 'upon or before the last day of November', directing that it should emulate the structure and appearance of the Swan, with their new playhouse to be called the Hope. Upon Henslowe's death in January 1616, his son-in-law Ned Alleyn acquired his interest in the theatre. Meade quickly moved to schedule additional days for bear-baiting during the winter, prompting a dispute with the resident players, whose company quit the Hope in February 1617, to perform at a newly built playhouse in Porter's Hall, Blackfriars. A representative wrote to Alleyn, 'I hope you mistake not our removal from the Bankside. We stood the intemperate weather, 'till more intemperate Mr. Meade thrust us over, taking the day from us which by course was ours.' From this point on, the Hope reverted to its predecessor's function and became known by its old title of 'Bear Garden', until the start of the Civil War in 1642 when Parliament prohibited animal baiting. It was sold for £1,783 15s on 14 January 1647 and, according to a contemporary note made in Stow's *Annals*, converted into tenements 'by Thomas Walker, a petticoat-maker in Cannon Street, on Tuesday, the 25 day of March, 1656. Seven of Mr. Godfrey's bears, by the command of Thomas Pride, then high sheriff of Surrey, were then shot to death on Saturday the 9 day of February, 1655[/56], by a company of soldiers'. Bear-baiting was revived at the Restoration of the Monarchy, and the Hope was refitted as a sporting arena. The venue enjoyed renewed success, with diarists Samuel Pepys and John Evelyn both describing visits to the Bear Garden prior to the removal of the 'royal sport of bulls, bears, and dogs' to Clerkenwell during the 1680s. By the time John Strype's updated and expanded edition of Stow's *Survey* was published in 1720, the building had been demolished, though the name endured: 'Bear Alley runs into Maiden Lane ... and about the middle is a new-built Court, well inhabited, called Bear Garden Square, so called as built in the place where the *Bear Garden* formerly stood, until removed to the other side of the water.'

Prior to the Burbages' loss of the Theatre site in 1597, playhouses had been erected and managed by businessmen – including James Burbage himself – who received the profits from 'the door' and retained the lion's share. James' sons, Richard and Cuthbert Burbage,

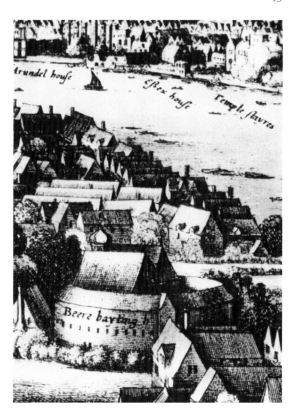

The Hope Playhouse, or Second Bear
Garden, 1647.

developed a groundbreaking new system, bringing together a stock company of celebrated
performers, who would have a shared interest in their theatre's collective ownership.
They selected John Heminges, Augustine Phillips, Thomas Pope, comedian William Kent,
and the 'upstart Crow' himself, William Shakespeare, the pre-eminent 'super troupe' of
early English drama; each was to receive one share (of ten), with the Burbage brothers
splitting the remaining five. The cost of leasing a new site, erecting a playhouse, and
running it would be divided among the syndicate according to their holdings, with profits
distributed in the same way. By becoming their own 'housekeepers' – and their junior
players' landlords – they could ensure both excellence and permanence at a time when
constant reorganisation caused by shifting allegiances was the norm.

With the 'how' established, the question shifted to 'where', and the existing foot traffic
generated by the Rose, the Swan, and the Bear Garden made Bankside the logical choice.
A verbal bargain was made with Sir Nicholas Brend to lease a plot of land near St Mary
Overies, neighbouring the Rose on its eastern side, to run from 25 December 1598. On
28 December, their carpenter Peter Street and his men deconstructed the Theatre and
famously transported its components across the river overnight, for reassembly (with
additional materials) as the Globe. A formal deed, with subsidiary contracts to follow,
was signed on 21 February 1599. Although the date on which it first opened is unknown,
it is likely to have been during the summer of 1599; the Inquisition Post Mortem of
the landowner's father, Sir Thomas Brend, dated 16 May, lists the building among his

properties, describing it as 'vna domo de novo edificata ... in occupacione Willielmi Shakespeare et aliorum': 'a house of new building ... in the occupation of William Shakespeare and others'.

Edmund Howes reports in his continuation of Stow's *Annals* that

> Upon St. Peter's Day last [29 June 1613], the playhouse or theatre called the Globe, upon the Bankside, near London, by negligent discharge of a peal of ordnance, close to the south side thereof, the thatch took fire, and the wind suddenly dispersed the flames round about, and in a very short space the whole building was quite consumed; and no man hurt: the house being filled with people to behold the play, *viz.* of Henry the Eight.

Ben Jonson and 'Water Poet' John Taylor were in the audience, both later commemorating the tragedy in verse.

The company relocated to their indoor playhouse at the Blackfriars, where they had performed during the winter season since 1608, but the shareholders suffered considerable financial loss, with further concern centred on the precarious state of their lease, soon due to expire and parcel of a complicated series of property transactions initiated by the death of Sir Nicholas Brend in October 1601, his eldest son and heir Matthew then being less than two years old. Sir Nicholas' half-brother, John Bodley, renewed the King's Men's lease on 26 October 1613, its term to run until 25 December 1635; on 14 February 1614, the Burbage brothers, John Heminges, and Henry Condell secured the signatures of Matthew and his mother Margaret (Matthew's guardian), further extending their term to 25 December 1644. It was then deemed safe to proceed, with a 'return' of 1634 recording that 'The Globe playhouse, near Maid Lane, [was] built by the company of players, with a dwelling house thereto adjoining, built with timber, about 20 years past, upon an old foundation.'

The Third Globe, 2018.

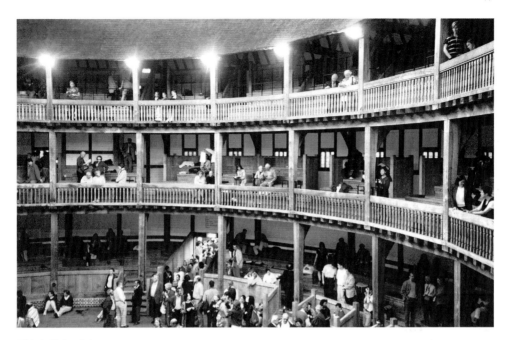

Third Globe debut season, 1997.

The Second Globe opened for the summer season of 1614, by which time Shakespeare was on the cusp of retirement; he died two years later, followed by Richard Burbarge in 1619. Shakespeare's plays were collated and published by their colleagues Heminges and Condell, who, with Cuthbert Burbage, followed them to the grave within the next twenty years. Meanwhile, Matthew Brend had recovered his property by decree of the Court of Wards and Liveries in 1622, and in 1633 attempted to break the lease he had ratified as a minor, so that he might rent out the property to other actors at a greater profit; the lessees successfully filed suit in the Court of Requests, confirming their right to occupy the Globe until 25 December 1644, but their tenure was ended prematurely by the Puritans' closure of all playhouses in 1642. Manuscript notes to a copy of Stow's *Annals* relate that the Globe was 'pulled down to the ground by Sir Mathew Brend, on Monday the 15 of April, 1644 [before the expiry of the lease], to make tenements in the room of it'. The site was later incorporated into the expanding Anchor Brewery, originally founded by James Monger Sr in 1616 on land adjoining the Globe.

Today's 'Third' Globe was opened by Queen Elizabeth II in June 1997, approximately 720 feet east of the original, directly below the river to the north – the posthumous realisation of director-producer Sam Wanamaker's quest to reconstruct the lost 'glory of the Bank', the new theatre sitting behind it, whose interior is inspired by the Second Blackfriars Playhouse, fittingly named in his honour.

Following the Restoration of the Monarchy in 1660, Drury Lane and Covent Garden enjoyed special privileges as London's two 'Patent Theatres'. Authorised to perform legitimate drama, their rights were protected by law until abolished by the Theatre Regulation Act of 1843. However, by the late eighteenth century unlicensed theatres in

and around London were tempting audiences with miscellaneous public entertainments and pantomimes, and St George's Fields, lying south of the western end of Bankside, was undergoing development. The Royal Circus and Equestrian Philharmonic Academy opened in 1782 on the western side of Blackfriars Road, close to its present-day junction with Westminster Bridge Road, on ground leased to the composer and songwriter Charles Dibdin and equestrian trick-rider Charles Hughes, with the early goal of training young performers. Under the management of Delphini, a renowned 'buffo' or comic actor in Italian opera, in 1788 spectacles including a real stag hunt were produced, followed by other animal acts, including the popular canine duo Gelert and Victor, as well as pantomimes. Comedian John Palmer became the theatre's next manager, until his imprisonment in Horsemonger Lane Gaol in 1789 as 'a rogue and a vagabond'. The edifice was twice damaged by fire between 1799 and 1805, and rebuilt to the designs of Rudolph Cabanel, architect of the 'Old Vic', in 1806. Converted for theatrical use by Robert Elliston, whose ambition was to stage the plays of Shakespeare and other respected dramatists, it was rechristened the Surrey Theatre for its reopening. To circumvent the law prohibiting spoken dialogue without musical accompaniment except at the Patent Theatres, Elliston inserted a ballet into every production. On his departure in 1814, the Surrey reverted to use as a circus, then reopened as a theatre in 1816 under the proprietorship of the actor, dramatist and songwriter Thomas Dibdin; he remodelled the equestrian arena into a large pit for spectators, and the stables into saloons, but his venture ended in failure and brought him to financial ruin.

DID YOU KNOW THAT...?

During the early years of the Surrey Theatre, contemporary reviewers noted that the neighbourhood was teeming with prostitutes – a Georgian equivalent of the Tudor playhouses and bear-baiting rings coexisting with Bankside's stews.

Elliston's return in 1827 brought renewed success, cemented by the Surrey's 1829 production of Douglas Jerrold's melodrama *Black-Eyed Susan*, which ran for over 300 nights. Following Elliston's death in July 1831, succeeding managers continued to attract large houses and long runs with melodramatic performances and adaptations of tales by Charles Dickens, a noteworthy appearance being that of the first successful black actor, Ira Aldridge, during the 1840s. On 29 January 1865, a fire began above the chandelier during the last scene of the pantomime *Richard Coeur de Lion*. While the audience was safely evacuated, the cast was trapped backstage when the supervisor cut the gas supply to prevent an explosion, plunging the theatre into darkness. Through the stalwart efforts of Acting Manager Green, Rowella the 'Clown', Evans the 'Pantaloon', Vivian the 'Sprite' and others, the still-costumed company was led through the burning set to a fleet of cabs outside, provided by police, which conveyed them to their lodgings; the theatre burned to

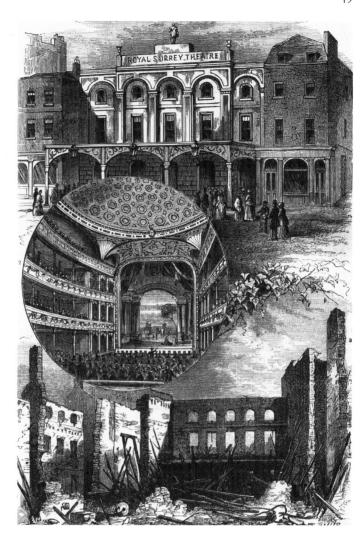

The Surrey Theatre, 1865.

the ground shortly after midnight. Its edifice was rebuilt yet again, with the new theatre, which boasted a seating capacity of 2,161 arranged in four tiers, opening on 26 December. In 1881, its management was taken over by George Conquest, whose repertoire of melodramas and pantomimes enjoyed considerable success until his death in 1901, when the Surrey's popularity went into an irrecoverable decline. It was converted for use first as a music hall, which failed, and then next as a cinema between 1920 and 1924. It then remained empty for ten years, until its demolition in 1934 to make way for an extension to the Royal Eye Hospital, now the site of McLaren House.

The late twentieth century continued the tradition of converting derelict properties into venues for the arts. Like Bankside Power Station (built between 1947 and 1963), which has provided a home for Tate Modern art gallery since May 2000, Southwark's Union Theatre and Menier Chocolate Factory embody the repurposing of an originally industrial structure to generate creative employment. Director Sasha Regan remodelled

Union Theatre Café & Bar, and Menier Chocolate Factory.

a disused paper manufacturer's warehouse to found her fringe venue on Union Street in 1998, garnering critical acclaim for its musical theatre productions and winning 'Up-and-Coming' Theatre at the Empty Space Peter Brook Awards in 2008. Despite its success and local popularity, the Union Theatre was given twelve weeks' notice to relocate, along with neighbouring small businesses, in 2015, when Network Rail decided to redevelop its picturesque site underneath railway arches as offices, with a campaign quickly launched to save the grounds. It relocated to new premises with improved facilities and a larger seating capacity in Old Union Arches, directly opposite its original home, in 2016.

A short distance north-west of Union Street, the five-storey factory and warehouse on Southwark Street was erected between 1865 and 1874 by Menier Chocolate Co., a French concern then expanding its interests overseas. Like Bankside Power Station, it was closed during the 1980s and reinvented for the New Millennium, reopening in 2004, and receiving the Empty Space 'Up-and-Coming' Theatre award the following year; in 2007 it was pronounced 'one of the most dynamic fringe venues in London' by the *Evening Standard*, and has won numerous awards for its productions in the years since. The large complex houses an art gallery, restaurant, and theatre, staging a diverse repertoire of plays, musicals, concerts, and stand-up comedy.

Southwark's newest commercial venture opened in October 2017 at No. 3 Potters Fields Park, on the western side of Tower Bridge. It was founded by the exiting Artistic and Executive Directors of the South Bank's National Theatre, Nicholas Hytner and Nick Star, to provide a home for their 'London Theatre Company'. The Bridge Theatre was designed by Steve Tompkins and Roger Watts as a flexible space, adaptable for proscenium arch, thrust stage, and promenade performance, with a generous 900-seat capacity, and a mandate to commission and produce new work as well as restage the 'classics'. Though not a 'famous theatre' as yet, its ability to combine the remits of both indoor and outdoor Elizabethan playhouses makes it an exciting successor to western Bankside's lost theatres, like them situated below the riverbank, giving Southwark's Blazon of Player and Pilgrim a new lease of life on its eastern shore.

4. Street Life

Borough Market first enters the historical record in 1276, but if the medieval Icelandic poet Snorri Sturluson is correct, it dates back to 1014, when he credits King Ethelred's ally St Olaf with ensuring victory against invading forces by pulling down London Bridge. Recounting the episode in the *Heimskringla* saga of *c.* 1230, Sturluson writes, 'First they made their way to London, and so up into the Thames, but the Danes held the city. On the other side of the river is a great market town called Southwark' ('Suthverki') – the *Anglo-Saxon Chronicles* make no mention of this incident, which casts doubt on London Bridge falling down, but does not disprove the existence of a produce market south of the bridge during the early eleventh century. An assize roll of 1258 records the customary practice that no trading should take place at the market in Southwark before morning mass had been celebrated at the hospital of St Thomas, but does not specify where the

The Bridge-foot, 1810.

market was located. From 1550, Southwark's designated opening days were Mondays, Wednesdays, Fridays, and Saturdays, as granted by the first Tudor monarch and confirmed in 1663, following the Restoration. A plan of Southwark dating to 1542 places the market directly to the south of St Margaret's Church on the west side of what is now Borough High Street, uncomfortably close to teeming Southwark Fair.

It was soon moved into the High Street itself, with courts leet ordering 'that no Collyer from hensforthe shall sett their cartes in the streate vppon the market daye ... for the cause is that yf ther shoolde be affraye made ther it is not possyble for no man to come & helpe, the cartes ther doo stande so thicke, that is betwene the Pyllory & Sainte Margretes Hill' in 1561, and that the 'Market shall be kept on the West side of the Channel of the High Street within this Borough begining at the Bridge Foot & ending at Compter Lane within Three Foot of the said Channel upon Pain that every one Standing out of that Verge shall pay vjs. viijd' (6 shillings 8 pence) in 1691. It remained there until 1754, when traffic congestion had become so severe that an Act of Parliament was passed to abolish the market so that it might be re-established on ground called 'the Triangle' in Rochester Yard, south-west of St Saviour's churchyard, where it stands today. John Entick noted

Borough Market, north entrance.

approvingly in his *Survey* of 1766 that 'On the west side of the *Borough* we meet with a good market for all sorts of provisions, removed to a more convenient place behind the houses, from the front street; where it was a great nuisance and obstruction to carriages and commerce.' The present-day market buildings were designed in 1851, with additions and improvements continuing throughout the nineteenth and twentieth centuries. Having survived the Blitz, it remained closed for eleven days after the attack on London Bridge on 3 June 2017, when three terrorists abandoned their van to pursue their strike in the market's surrounds, and reopened with a continuing commitment to the 1754 Act, which directed it to be 'an estate for the use and benefit' of the local community 'for ever'. Not for weeks or months or even centuries, but for all eternity'.

Frost Fairs were held on the Thames during what became known as the 'Little Ice Age', when the river periodically froze over in winter between the seventeenth and nineteenth centuries. Food and ale stalls were erected on the ice, and merrymakers enjoyed a vast range of entertainments – plays, music, dancing, stilt-walking, animal baiting – in addition to the traditional winter sports of curling, sledding, and skating, with inevitable tragic loss of life when the ice broke through. The diarist John Evelyn described the 'Great Frost' of 1683–84, which lasted for two months, the ice solid to a depth of 11 inches: 'Coaches plied from Westminster to the Temple, and from several other stairs too and fro, as in the streets; sleds, sliding with skeetes, a bull-baiting, horse and coach races, puppet plays and interludes, cooks, tipling and other lewd places, so that it seemed to be

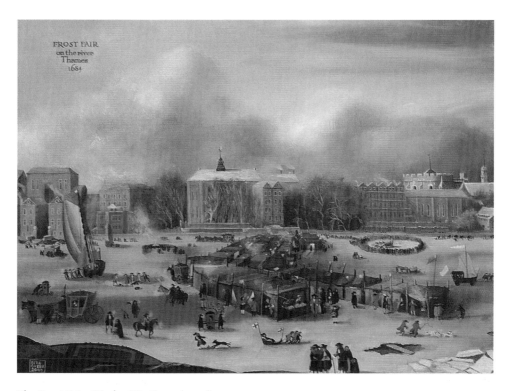

The Frost Fair 1684, by Rita Greer (2009).

a bacchanalian triumph, or carnival on the water'; a second account reports that 'On the 20th of December, 1688 [*sic.* – 1683], a very violent frost began, which lasted to the 6th of February, in so great extremity, that the pools were frozen 18 inches thick at least, and the Thames was so frozen that a great street from the Temple to Southwark was built with shops, and all manner of things sold'. George Davis' *Frostiana: or a History of the River Thames in a Frozen State*, printed in a stall erected on the river, commemorates the last Frost Fair of 1–4 February 1814, during which an elephant was led across the Thames under Blackfriars Bridge. The frost tradition was revived in 2003 as part of the Bankside Winter Festival, whose market stalls remain safely on land.

Southwark Fair, aka Our Lady Fair (beginning at the Feast of the Nativity of the Virgin Mary), was granted in 1443 by a charter of King Edward IV to the City of London (regranted in 1462), with the right to hold a Court of Piepowder – a tribunal with unlimited jurisdiction over malfeasance at fairs and markets. Its stalls and booths extended from Borough High Street, near St George's Church, through alleys and courts, onto the bowling greens, and its duration progressively expanded from three days to two weeks. A proclamation was issued to forbid the holding of the fair in 1630 due to an outbreak of plague – as a place where large crowds congregated, like the playhouses, it was regulated as a breeding ground for disease.

DID YOU KNOW THAT...?

Oliver Cromwell's Protectorate unsuccessfully sought to suppress Southwark Fair, with numerous entries in St George's Parish Overseer's Accounts between 1656 and 1660 listing fines for 'Abuses and Misdemeanours' during fair time, entertainers, proprietors, and victuallers likewise paying dues.

The city's right to hold the fair was reconfirmed in 1663, and its popularity continued, with entertainments including singers, dancers, puppet and clockwork shows, and, inevitably, players. When Elkanah Settle's tragi-comedy *The Siege of Troy* was printed *c.* 1707, its subtitle proclaimed it 'A Dramatick Performance, Presented in Mrs Mynn's Great Booth, in the Queen's-Arms-Yard near the Marshalsea-Gate in Southwark, during the Time of the Fair'. In 1728, 'Fielding and Reynold's Great Theatrical Booth' was 'at the lower end of Blue Maid Alley', with 'a commodious passage for the Quality, and coaches through the Half Moon Inn'; and Mrs Lee likewise had a 'Great Booth', on 'the Bowling-Green, Southwark', where 'Comedians from the Theatres' performed in 1732, by which time the atmosphere was more frenetic. In 1712, *A Merry New Year's Gift* referred to the 'Bartholomew Fair, which they keep up still in the borough, though it be left off in the city', suggesting that fairs were becoming increasingly unruly. William Hogarth's 1733 engraving of *A Fair, the Humours of a Fair* loosely follows Southwark's topographical details, chiefly concerned with capturing the raucous energy of the crowd – in the same year, a woman was crushed to death during the fair, in Mermaid Court, north-east of the church.

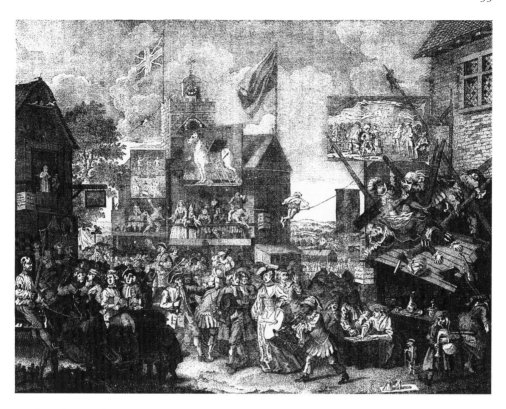

Southwark Fair (after Hogarth's picture).

The bailiff was ordered to terminate his proclamation of Southwark Fair in 1762, and in 1792 it was officially discontinued by order of the Lord Mayor.

During the eighteenth century, pleasure gardens became the height of fashion, and Southwark could boast of several. The Dog and the Duck Inn had stood in St George's Fields since at least 1642; mineral springs nearby, believed to share the restorative property of the Spa waters in Bath, increased its popularity between 1754 and 1770 – Samuel Johnson recommended them to his friend Mrs Thrale, whose husband Henry had inherited the Anchor Brewery from his father in 1758, and served as MP for Southwark from December 1765 to September 1780. The Dog & Duck then offered a breakfast room, bowling green, swimming bath, and tea garden, with St George's Spa hosting music and dancing in its Long Room. The clientele had degenerated by 1775, and in 1799 the gardens were closed, with Bethlehem Hospital built on their site in 1812, the sign of the Dog & Duck, pictured in Hogarth's *Southwark Fair*, incorporated into its boundary wall.

Finch's Grotto Garden was opened by heraldic painter Thomas Finch in 1760 on the western side of St George's Street, bounded by Dirty Lane (today, Great Suffolk Street) to the south, thus operating within the permissive 'Rules' of the King's Bench Prison. Surrounded by greenery, the grotto was built over another spring that was said to be medicinal; concerts and balls were held in its Octagon Room, and an orchestra played in the grounds, where fireworks were displayed. Mrs Hardcastle – playwright Oliver

Goldsmith's prototype Hyacinth Bucket – asks in Act II of *She Stoops to Conquer* 'Who can have a manner that has never seen the Pantheon, the Grotto Gardens, the Borough, and such places where the nobility chiefly resort?', its patrons, by implication, being as unfashionable as the seedy residents of the Mint. The grotto was demolished in 1773, its plot converted to a tavern skittle ground. In 1777, St Saviour's parish purchased the gardens, with one part used as a burial ground and the remainder demolished to make way for the construction of Southwark Bridge Road.

Self-taught artist Thomas Keyse purchased the Waterman's Arms in Bermondsey in 1765, along with 4 acres of surrounding wasteland, which he converted into a tea garden, setting out benches amid arbours, and placing his work on permanent display. In 1770, he either discovered or created a 'chalybeate' (ferrous) spring – again thought to have curative powers – leading to the venue becoming known as Bermondsey Spa Gardens. Keyse secured a licence for music and spent £4,000 on enhancements modelled on Vauxhall Pleasure Gardens, whose success he hoped to emulate, staging elaborate firework displays, including a set-piece pyrotechnic Siege of Gibraltar designed and built by himself. However, Bermondsey's more remote location prevented it from becoming a second Vauxhall, and the gardens closed five years after Keyse's death in 1800, living on in the name of Spa Road.

Today's Bermondsey Spa Gardens, originally Spa Park, was opened on nearby Grange Road in 1954, on the site of two terraced streets that had been devastated by enemy action during the Blitz. It was closed in 2005 for redevelopment, and reopened in March 2006, its enhanced amenities including a new play centre for children.

Mint Street Park, a parallel oasis of green space in Borough, takes its name from the area's familiar title since the mid-1540s, but shares more in appearance with its origin as

Bermondsey Spa Gardens.

a mansion surrounded by gardens. When Charles Brandon – later Duke of Suffolk and brother-in-law to King Henry VIII – succeeded his uncle to the office of Marshal of the King's Bench in 1510, he erected a 'large and sumptuous house' near the prison, opposite St George's Church, west of Borough High Street, on a site leased by his family from Bermondsey Abbey for generations, known as Suffolk Place. Brandon surrendered it to the Crown in 1536 in exchange for Norwich House in St Martin-in-the-Fields, which took on the name of Suffolk Place; the Borough mansion was settled on Queen Jane (Seymour) as part of her jointure and rechristened Southwarke Place. A Royal Mint was established there by King Henry VIII *c.* 1545, ceasing operations when fraud was discovered during the reign of Queen Mary I, who granted the property in 1556 to the Archbishop of York, Nicholas Heath, as compensation for her father's annexing of the archbishop's York Place to Westminster Palace; Heath promptly sold it and purchased Suffolk Place/Norwich House.

Stow reports in his 1598 *Survey* that the merchant (or merchants) who bought Southwarke Place 'pulled it down, sold the lead, stone, iron, &c.; and in place thereof built many small cottages of great rents, to the increasing of beggars in that borough'. Sir Edward Bromfield, Lord Mayor of London, paid £1,700 for the property in 1636, and in 1651 – during the Commonwealth – it was surveyed by pretext of its grant to the Archbishop of York having been illegal; in addition to its capital messuage and precincts, a tenement was situated in the 'Great Mint Garden', with a further fourteen tenements recorded on the estate, the majority having a garden plot attached.

Thomas Lant, who acquired the property after his marriage to Sir Edward's great-granddaughter Joyce Bromfield, successfully petitioned the House of Lords in 1702 for a bill enabling him to make leases at the best possible rent, which he had previously been unable to achieve, the tenements being 'unrepaired, Unlet and Ruinous', presumably inspiring the name of Dirty Lane to the south.

DID YOU KNOW THAT...?

Thomas Lant gave his name to the street formed in 1770, running below Mint Street and above Great Suffolk Street, in which Charles Dickens lodged as a child while his father was imprisoned for debt in the Marshalsea in 1824. In his *Pickwick Papers*, Dickens places Bob Sawyer as a lodger in Lant Street, wryly noting that 'The majority of the inhabitants either direct their energies to the letting of furnished apartments, or devote themselves to the healthful and invigorating pursuit of mangling.'

Lying as it did within the 'Rules' of the King's Bench Prison, the Mint had accrued firm rights and privileges, including immunity from arrest, as a Liberty, and was notorious during the eighteenth century as a resort for coiners, thieves, and highwaymen, including Jack Sheppard and Jonathan Wild. One resident wrote a 'True Description of the Mint' in 1710, dividing inhabitants into three categories: firstly, 'Benchers' sentenced to prison,

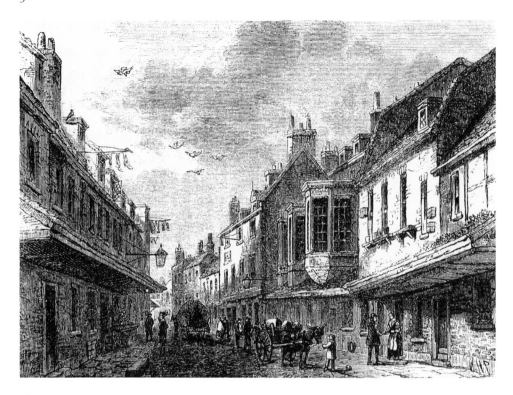

The Mint, 1825.

who paid 2s 6d to the marshal weekly for the liberty of the Rules, as security they would not escape, their territory running from just below the King's Bench to St George's Church, including the Mint up to its southern boundary ditch at St George's Fields; secondly, 'Shelterers' who feared arrest for debt, having a greater liberty extending beyond the boundary ditch; thirdly, a motley group of householders and former prisoners the author calls 'minters and inhabitants', who had no geographic restrictions. An earlier Act of Parliament having proved ineffectual during the reign of King William III, a dedicated Act was passed in 1722 which effectively stripped the Mint of its protected status. By 1811, when the property was sold at auction in ninety-eight lots, it contained 600 dwellings generating £2,000 yearly in rents.

Until they were outlawed in 1546, the row of licensed brothels collectively known as the 'Stews' enjoyed a similar freedom to the Liberty of the Mint at Bankside, falling under the jurisdiction of the Bishop of Winchester, who licensed the prostitutes working there. Stow's *Survey* records the 'old customs' to be enforced, as confirmed in Parliament during the eighth year of the reign of King Henry II:

No stew-holder to keep any woman to board, but she to board abroad at her pleasure.

To take no more for the woman's chamber in the week than fourteen pence.

Not to keep open his doors upon the holidays.

Not to keep any single woman in his house on the holidays, but the bailiff to see them voided out of the lordship.

No single woman to be kept against her will that would leave her sin.

No stew-holder to receive any woman of religion, or any man's wife.

No single woman to take money to lie with any man, but she lie with him all night till the morrow.

No man to be drawn or enticed into any stewhouse.

The constables, bailiff, and others, every week to search every stew-house.

DID YOU KNOW THAT...?

Due to the 'sin' attached to their profession, the Winchester Geese (prostitutes) were excluded from church rites and Christian burial. John Stow reports that 'therefore there was a plot of ground called the Single Woman's churchyard, appointed for them far from the parish church', on unconsecrated ground. Used as a pauper cemetery by the mid-eighteenth century, it was closed in 1853, deemed 'completely overcharged with dead'.

The Single Woman's burial site in Red Cross Way, now known as Cross Bones Graveyard, was excavated between 1991 and 1998; archaeologists confirmed its 'overcharged' condition, with bodies deeply piled one on top of another, and testing revealed the dead to have suffered from smallpox, tuberculosis, Paget's disease, osteoarthritis, and Vitamin D deficiency. The volunteer Friends of Crossbones have worked to protect the site since 1996, collaborating with the 'Invisible Gardener' to create a 'secret guerrilla garden' between 2006 and 2012, and with Bankside Open Spaces Trust since 2015 to maintain the 'Garden of Remembrance' for 'the Outcast Dead'. *The Southwark Mysteries*, a contemporary mystery cycle by John Constable, inspired by the Geese and their graveyard, was first performed at the Globe and Southwark Cathedral on Easter Sunday, 23 April 2000; I was fortunate to visit the graveyard during the run of the eerily evocative sound installation 'Requiem for Crossbones' by Emily Peasgood, developed for MERGE Bankside, in June 2018.

The name Cardinal's Hat, aka Cardinal's Cap, has been recorded at Bankside since the reign of Queen Elizabeth I, and is among the brothels described by Stow in his *Survey* as having 'signes on their frontes, towardes the Thames, not hanged out, but painted on the walles, as a Beares heade, the Crosse Keyes, the Gunne, the Castle, the Crane, the Cardinals Hatte, the Bell, the Swanne, etc.' – though it may simply have been an inn, now surviving only in the form of the narrow medieval alley that ran down along its western side. It was characterised as 'a void piece of ground' in 1470, with no existing structure mentioned in the site's bill of sale in 1533. Hugh Browker, who would buy the Manor of Paris Garden in 1602, held the land in 1579, and may well have constructed the alley and adjacent building, as Token Books label it 'Mr. Broker's Rentes' in 1588 and describe it as in the occupation of John Raven in 1593. When the actor Ned Alleyn dined there in December 1617 with the 'vestrye men' of St Saviour's parish, it was in the tenancy of Thomas Mansfield, and 'Water Poet' John Taylor dined there a few years later with 'the Players'. Between 1627

The Crossbones Graveyard.

Cardinal's Wharf and Cardinal Cap Alley.

and 1674, its tenant was brewer Melchisedeck Fritter, who appears in hearth tax rolls, assessed for seven hearths. Thomas Browker sold the freehold in 1667 to Thomas Hudson, who bequeathed his 'messuages on Bankside' to his sister, Mary Greene, in 1688. The inn was comprehensively rebuilt during the early eighteenth century.

On the alley's eastern side, an elegant early eighteenth-century cream-painted house bears an elaborate plaque commemorating Sir Christopher Wren's residency during the building of St Paul's Cathedral (more likely to have been in a house to the east, where a modern block of flats now stands). The Cardinal's Wharf plaque continues, 'Here also in 1502, Catherine Infanta of Castille & Aragon, afterwards first Queen of Henry VIII took shelter on her first landing in London', almost directly opposite Blackfriars Monastery, north of the Thames, where the king's suit to divorce her would be heard twenty-seven years later.

5. Correction and 'Comfortable Works'

Southwark's position near to, yet outside, the City made it a convenient site for the detention of lawbreakers at a safe distance from London and the royal Palace of Westminster, the facilities lying side by side – sometimes inside – the inns on Borough High Street, and housing courts as well as jails. In his *Survey* of 1598, John Stow reports that there were then five prisons: 'The Clinke on the Banke'; 'The Compter, in the late parish church of St. Margaret'; 'The Marshalsey'; 'The Kinges Bench'; 'And the White Lion, all in Long Southwarke'.

Sitting between Winchester House to the east, the riverbank to the north, and a common sewer bounding its western side, the Clink was owned by the Bishop of Winchester, whose steward and bailiff heard pleas for debt and damages there; the Pillory, Cucking Stool (with scolds-bridle), and Cage stood nearby, on what is now Clink Street. Stow's description highlights the direct connection between its geographic locale and the type of transgression punished within it: 'next [to the Stews] is the Clinke, a gaol or prison for the trespassers in those parts; namely, in old time, for such as should brabble, frey, or break the peace on the said bank, or in the brothel houses, they were by the inhabitants thereabout apprehended and committed to this gaol, where they were straitly imprisoned'. It is first mentioned by name in a list of alms distributed to the poor 'at the Clynke' on 28 April 1509, at the funeral of King Henry VII. During the reigns of queens Mary I and Elizabeth I, it was a seat for the trial of religious 'heretics', as well as incarceration. Foxe's *Book of Martyrs* relays Protestant reformer John Rogers' account of his conveyance with Bishop Hooper after their trial before Bishop Gardiner, the sheriffs taking them under cover of darkness, 'with billes and weapons enowe, out of the Clink, and led vs thorow the Byshops house, & so thorow Saynte Marie Ouerayes churchyeard, and so into Southwerke, and ouer the bridge on procession to Newgat'. The Clink went into decline following the sale and conversion of Winchester House in 1649; in 1720, John Strype's updated and expanded edition of Stow's *Survey* noted it to be 'of little or no concern'. It was so decayed by 1745 that its prisoners were relocated to a house on Bankside; the area was razed during the Lord George Gordon riots of June 1780, and it was not rebuilt. Today, the Clink Prison Museum stands on its original site.

We have already met the old Sessions Courthouse and Compter prison in the form of St Margaret's Church, demolished in 1791. That same year, 3½ acres of ground adjoining Horsemonger Lane in Newington were purchased by the Surrey Justices for the foundation of a new Gaol and Sessions House, designed by George Gwilt the elder. Charles Dickens witnessed the hanging of Marie and Frederick Manning from the gibbet at Horsemonger Lane Gaol, writing an outraged letter to *The Times* on 13 November 1849, which effectively began a campaign against public executions, finally abolished in 1868. The gaol was closed in August 1878, and its inner quadrant cleared in 1880; a children's

Left: The Clink Prison Museum.

Below: Inner London Sessions Crown Court.

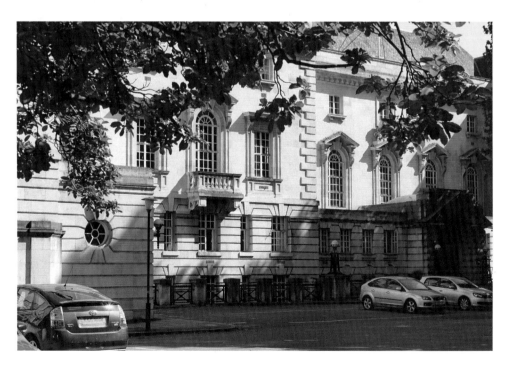

playground was opened on 1 acre of its grounds in January 1884. The rest of its buildings were demolished in 1893, with Newington Gardens – familiarly known as 'Jail Park' until the 1960s – now occupying part of its site. The Sessions House on the north-west side of the prison remained in use until 1912, after which it was replaced by today's Inner London Sessions House Crown Court, which was opened in 1917 on the corner of Harper Road and Newington Causeway, at the bottom of Borough High Street.

The Court of the Marshalsea, also known as the Court of the Verge, was a jurisdiction of the Royal Household, its 'verge' or radius extending within 12 miles of the reigning monarch; as a result, the court was 'ambulatory', travelling throughout the realm. Stow explains that its attendant prison was 'so called, as pertaining to the marshals of England. Of what continuance kept in Southwark I have not learned; but like it is, that the same hath been removable, at the pleasure of the marshals'. He notes its presence in Borough at Easter in 1377, when 'John, Duke of Lancaster, having caused all the whole navy of England to be gathered together at London: it chanced a certain esquire to kill one of the shipmen, which act the other shipmen taking in ill part, they brought their suit into the king's court of the Marshalsey, which then as chanced (saith mine author) was kept in Southwarke'. By the time John Entick published his *Survey* in 1766, the verge was centred on the royal Palace of Westminster rather than the royal personage:

> On the east side of this street, called *St. Margaret's-hill* [now Borough High Street], there is the *Marshalsea prison* and *court*. In which are confined all persons committed for crimes at sea, as pirates, &c. and for debt by land. The judges of the court are, the lord steward of the king's houshold; a steward of the court, who must be a barrister at law; and a deputy steward. In all civil actions, tried in this court, both the plaintiff and defendant must belong to his majesty's houshold. The persons confined in this prison for crimes at sea are tried at the *Old bailey*.

Like Southwark's other gaols, its inmates included Catholic recusants during the 1580s, and the Earl of Essex's men following his failed rebellion of 1601, after which it increasingly held debtors from the general population, though it remained the Court of Admiralty's prison until the Marshalsea was abolished in 1842. Its fabric had become ruinous by 1799, when the old County Gaol house – the White Lion – was purchased and converted into a new Marshalsea, which continued there from 1811 until its closure. It is this second Marshalsea that Charles Dickens memorialises in *Little Dorrit* as 'an oblong pile of barrack building partitioned into squalid houses standing back to back, so that there were no back rooms; environed by a narrow paved yard, hemmed in by high walls duly spiked at top', his father John having been incarcerated there for a debt of £10 between February and May 1824. Only its southern boundary wall next to St George's churchyard remains, the site now occupied by Southwark Council's John Harvard Library and Local Studies Library.

The King's Bench Prison originally stood on the east side of St Margaret's Hill, between the White Lion Gaol and the Marshalsea, and like the Marshalsea dates from the fourteenth century, though its jurisdiction as a centre of national administration reaches

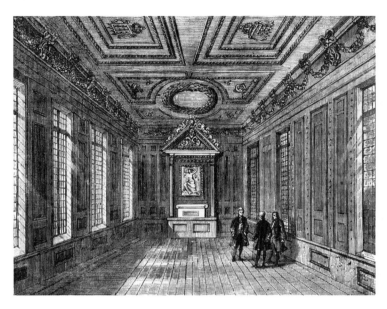

Interior of the
Palace Court of the
Marshalsea, 1800.

back to the reign of King Alfred the Great. Stow explains its position south of the Thames: 'I have read that the courts of the King's Bench and Chancery have ofttimes been removed from London to other places, and so hath likewise the gaols that serve those courts.'

In 1373, 'the good men of the town of Suthwerk' were granted a licence 'to build in the high street leading from the church of St. Margaret towards the south, a house, 40 feet long and 30 feet wide, in which to hold the pleas of the Marshalsea of the king's household and to keep the prisoners of the Marshalsea while in the said town, and to hold all other the king's courts' – there were now two distinct prisons, respectively serving the Court of the Marshalsea and the Court of King's Bench. Wat Tyler's men freed the prisoners in both during the Peasants' Revolt of 1381, as did Jack Cade during his occupation of Southwark in 1450. Entick's *Survey* reveals that while the province of the Court of King's Bench, like the Marshalsea, extended within a 12-mile radius of the Palace of Westminster, 'the city of *London* excepted', it excluded matters pertaining to the Household: debtors

> may be arrested and carried to this prison for a debt of 40s. Actions for debt are tried in this court every *Friday*: and there are the same judges as in the *Marshalsea court*, and a protho-notary, a secondary, and deputy protho-notary, 4 counsellors, and 6 attorneys. But in this court neither plaintiff nor defendant must belong to his majesty's houshold. The buildings are run much to decay: but there is a spacious and convenient court-room.

While its inmates were chiefly charged with insolvency, a list of seventy-one prisoners dating to 1561 records that thirteen were debtors, three recusants, one a priest, with two persons arraigned for 'inconjuracion' (witchcraft), the rest for felonies and misdemeanours. They were held in two houses known as 'the Angel' and 'the Crane', whose owner, Richard Fulmerston, erected a new building enclosed by a brick wall 'for ye more

safe Custody of the Prisoners' during the reign of King Henry VIII. Playwright Thomas Dekker was incarcerated there between 1612 and 1619 on a plea of debt for £40 filed by the father of fellow dramatist John Webster; Dekker continued to write pamphlets during the seven-year confinement, which, by his own report, turned his hair white, resuming his theatrical career soon after his release.

The first King's Bench was demolished in 1761; the second, built in 1758 near St George's Fields, is described by John Entick in his *Survey*:

> Near the north-east corner of this new road [now Newington Causeway] stands *the Kings-bench-prison*, a place of confinement for debtors, and for every one sentenced by the court of *Kings-bench* to suffer imprisonment: but those who can purchase the liberties have the benefit of walking through *Blackman-street* and a part of the *Borough*, and in *St. George's fields*. It is a new brick building, in a fine air, and surrounded with a very high brick wall: without which inclosure the marshal, who has the keeping of this gaol, has very handsome apartments. Prisoners in any other gaol may remove hither by *habeas corpus*.

It was closed and demolished soon after its acquisition by the Home Office during the 1870s, its site now occupied by a housing estate.

The White Lion stood on the east side of St Margaret's Hill, between St George's Church and the King's Bench Prison, described in a deed of sale dating to 1535 as a great tenement or inn, with a shop either side, a barn, stables, and an acre of common pasture land in St George's Fields. In 1598, John Stow reported it to be 'a gaol so called, for that the same was a common hosterie for the receipt of travellers by that sign. This house was first used as a gaol within these forty years last'; however, it does not appear

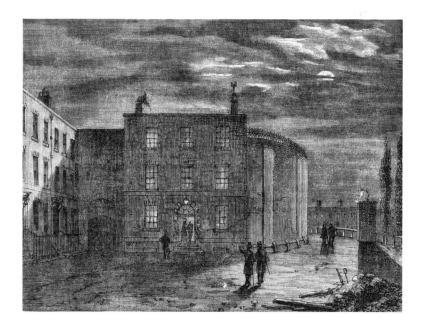

The King's Bench, 1830.

amidst the row of inns pictured in a (hand-drawn) 1542 Plan of Southwark, and is not named with them in a manorial survey of 1555, suggesting its conversion may have taken place earlier than Stow remembered. Ostensibly a debtors' prison run for profit by a succession of keepers, recusants were also incarcerated there during the reign of Queen Elizabeth I.

DID YOU KNOW THAT...?

Conditions at the White Lion had deteriorated so severely by the second quarter of the seventeenth century that George Coks, a Benedictine monk jailed there in 1638, complained that his life was endangered by the stale airlessness of the prison, pleading for transfer to the Clink as the lesser of two evils.

By 1666, the still useable sections of the White Lion were in such poor repair that the keeper was forced to consign its inmates to the Marshalsea, this recurrently temporary measure becoming permanent in 1695 with the agreement of the sheriff. The second Marshalsea was eventually built on its site in 1811, as related above.

Distinct from courts baron, which were held to oversee the management of the medieval manor, courts leet were concerned with matters of royal prerogative governed by their local jurisdiction, relating to petty criminal and anti-social behaviour. In 1766, John Entick noted 'There are also, besides this, three court-leets held in the *Borough*: for it contains three liberties or manors, *viz.* the great liberty, the guildable, and the king's manor, in which are chosen constables, aleconners, &c. and other business is dispatched peculiar to such courts.' Penalties were usually financial, but the Borough also had its Pillory, Whipping Post, and Cage, which the 1542 Plan of Southwark places a short distance south-east of St Olave's Church, near the boundary of the Gildable Manor and Great Liberty.

Consistory (ecclesiastic) Courts were established by a charter of William the Conqueror, with the remit of supervising church discipline and general morality, including defamation and matrimonial suits. They have continued through the Reformation to the present day, though their moral prerogative had waned by the end of the eighteenth century, with defamatory causes heard in temporal court from 1855, and the Divorce Court created in 1857.

The Church was responsible for charitable care as well as moral correction. 'The Loke lazar-house' was founded by the early 1300s as a hospital for lepers at the south-east end of Kent Street, now Tabard Street, surrounded by open fields within the parish of St Mary Newington. Its dedication to the blessed Mary and to Saintt Leonard, the patron saint of captives, is especially appropriate for a house which was in part a place of incarceration, separating afflicted persons from the 'sound' citizenry of London, but equally a place of shelter, where inmates were fed, clothed, lodged, and cared for at a safe distance from a fearful general populace. On 4 June 1315, King Edward II ordered that its master and brethren receive protection from molestation for one year, the first of a number of such

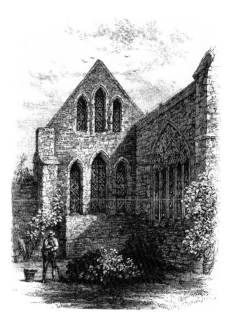

Above left: Consistory Court, St Saviour's Church, 1820.

Above right: Chapel of the Hospital for Lepers called Le Lock, 1813.

directives. Unlike the pocked single women of the Stews, those stricken with leprosy enjoyed the benefit of clergy; Stow relates that

> I read, that in a provincial synod holden at Westminster by Hubert, archbishop of Canterbury, in the year of Christ 1200, the 2nd of King John, it was decreed ... that when so many leprous people were assembled, that might be able to build a church, with a churchyard, for themselves, and to have one especial priest of their own, that they should be permitted to have the same without contradition.

It is likely that the Lock Hospital contained such a chapel, which was later rebuilt: seventeenth-century antiquary John Aubrey noted that its chapel door then bore the date 1636. The disease dwindled out by the late sixteenth century, with the final lepers admitted to the Lock in 1557, after which increasing numbers of its patients suffered from venereal disease, inspiring its nickname 'the Hospital for Pockey Folks in Kent Street' – the term 'lock hospital' today denotes an infirmary for the treatment of sexually transmitted diseases. After the Restoration, guardianship of the Lock was transferred to St Bartholomew's Hospital, which leased out its buildings in 1760. Part of the chapel and parlour survived, converted for use as a shop and dwelling houses, until the formation of Great Dover Street; its site is now occupied by the roadway and blocks of modern flats.

St Thomas' Hospital was originally situated south of London Bridge on the east side of Borough High Street. As Stow reports, it was 'first founded by Richard Prior of Bermondsey, in the Selerers ground against the wall of the monastery, in the year 1213,

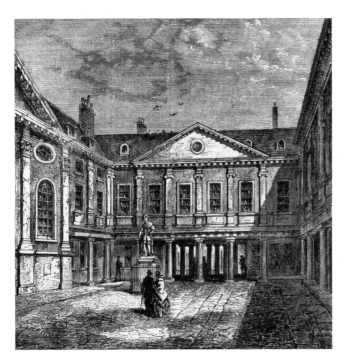

St Thomas' Hospital, 1840.

he named it the Almerie, or house of alms for converts and poor children; for the which ground the prior ordained that the almoner should pay ten shillings and four pence yearly to the Selerer at Michaelmas'. In 1215, Peter de Rupibus, Bishop of Winchester, refounded it for the Canons Regular, enlarging the building and increasing its revenue to £343 yearly. Originally held of the Prior and Abbot of Bermondsey, it was valued at £266, 17 shillings and 6 pence on its surrender to King Henry VIII in 1538, following the Dissolution of the Monasteries. In 1551, the City of London purchased the Manor of Southwark and the Hospital of St Thomas from King Edward VI, repairing and enlarging the suppressed infirmary in July 1552, with patients admitted from November. King Edward incorporated its governors with those of Bridewell, Bethlehem, and Christ Church hospitals the following year, and directed in his charter dated 26 June 1553 that St Thomas' be called 'the King's hospital in Southwarke'. By 1699, the fabric of the building had decayed to such a degree that it was demolished and built anew to a larger and grander design, funded by voluntary subscriptions, and executed in stages. John Entick's description perfectly matches the illustration above, filling in invisible detail:

[It] now consists of three quadrangles, or square courts. Into which we enter through a gate way, consisting of two stone piers, upon which are hung a pair of large iron gates, with a door of the same work on each side, for foot passengers: and on the top of each of those piers is a statue, representing one of the patients. These gates open into a very neat square court, encompassed on three sides with a colonade. The center of the principal front, facing the street, is of stone. There is a clock under a small circular pediment, and beneath that King *Edward* VI. holding a gilt scepter in his right hand, and the charter in his left. A little

lower, in niches on each side, is a man with a crutch, and a sick woman; and under them, in other niches, a man with a wooden leg, and a woman with her arm in a sling.

Although targeted rebuilding enabled it to survive the construction of an approach road to the new London Bridge station, which opened in 1836, plans to extend the railway to Charing Cross with a viaduct running straight through the hospital's site resulted in its compulsory purchase – recommended as a preferable alternative to selling components piecemeal by Florence Nightingale, who had opened the first school of nursing at St Thomas' in 1860. Queen Victoria laid the foundation stone at its present base in Lambeth in 1868, where the hospital opened three years later. The old infirmary was demolished, with only one ward, a row of houses in St Thomas Street – including the façade of the lodging shared by the poet John Keats and his friend Henry Stephens in 1815–16 while they were students at Guy's Hospital – and the former church still standing today.

Bermondsey-born Thomas Guy, a governor and benefactor of St Thomas', paid for the erection of its two new wings in 1721, and leased a parcel of land from the hospital with a view to providing care for the incurable and mental patients who were excluded from admittance there, creating what Entick called

the greatest endowment that ever was made by one person, especially one in private life. It is *Guy's hospital* for sick and wounded. ... It is situate in a very narrow street, which deprives the spectator of a proper view of this building, into which we enter by a very elegant and noble iron gate, hung on very handsome piers, which open into a square: in the middle of which is a brazen statue of the founder in his livery gown, and very well executed.

Guy's Hospital opened in 1724, shortly after its founder's death, and has expanded greatly during its near 300-year history in Southwark, merging in 1993 to form the Guy's and

Guy's Hospital.

St Thomas' NHS Trust, though its original courtyard facing St Thomas Street remains recognisable today.

The first Bethlem Hospital was founded in the priory of St Mary of Bethlehem in Bishopsgate Without, north of the river, its site now occupied by Liverpool Street station. It is named in a Patent Roll entry dated 23 September 1329, which does not specify the ailments treated there, but a 'Visitation' of the hospital filed within Ecclesiastical Chancery Miscellanea confirms that in 1403 its patients suffered from the mental disorders that gave rise to its nickname of 'Bedlam', which in turn became a blanket term for all psychiatric asylums, and synonymous with chaos and confusion. Following the Dissolution of the Monasteries, the Mayor and Commonalty of the City of London purchased St Mary of Bethlehem in 1547, and King Henry VIII issued Letters Patent to re-establish it as a hospital for lunatics. It was placed under the management of the governors of Bridewell in 1557, and in 1676 moved to a new building in Moorfields, where it remained until the end of the eighteenth century. In 1800, when the hospital surveyor determined that its fabric had become dangerous, its governors began to search for a new site. After lengthy deliberation, they chose 'certain land lying in St. George's Fields being the site lately occupied by the Dog & Duck and at present held by Mr. Hedger under the Bridge House Estates' in 1807. In 1810, the governors exchanged their Moorfields lease, which had a term of 963 years still remaining, with the City Corporation for a lease of 11¾ acres of triangular-shaped swampy ground in St George's Fields of equal duration. The foundation stone was laid on 18 April 1812; construction was completed in October 1814, and in August 1815 122 patients were transported from Moorfields to St George's Fields by hackney coach. Criminal blocks with accommodation for fifteen women and forty-five men were added in 1816, the men's quarters enlarged in 1835 to house a further thirty inmates, with wing blocks erected at either end of the frontage, and two long galleried blocks across the back garden.

Bethlehem Hospital.

In 1926, an Act of Parliament endorsed the construction of new premises in the rural setting of Monks Orchard at Addington, and in 1930 Viscount Rothermere purchased the St George's Fields freehold, entrusting it to the London County Council for the establishment of Geraldine Mary Harmsworth (public) Park, named in remembrance of his mother. Bethlehem's side wings were demolished, the central front edifice and rear galleries leased to the Commissioners of Works.

DID YOU KNOW THAT...?

Bethlem Hospital is still standing, though its sides have been radically truncated and two large canons now sit in front of its four central pillars – walking through the doors of today's Imperial War Museum, one is coincidentally entering 'Bedlam'.

The Imperial War Museum was opened in 1936; although it suffered extensive bomb damage during the Blitz, it reopened its galleries sequentially as repairs were completed in stages, in November 1946, 1948, and 1949.

'King Edward's School' – an orphanage founded as Bridewell Royal Hospital by King Edward VI and Nicholas Ridley in 1553 – was established next to Bethlem Hospital on its eastern side in 1828, when its governors leased the land to the governors of the Bridewell for a term of sixty-one years, to build 'a House of Occupations for the employment and relief of destitute of both sexes'. In 1867, the school relocated to Witley, near Godalming, where it remains today; its old buildings were demolished in 1931, and the Geraldine Mary Harmsworth Sports Facility now occupies its former site.

It was the historic norm for religious houses and parishes to be responsible for the education of their congregants, with the reigning monarch's seal of approval required for new building. St Saviour's Church wardens were granted Letters Patent in 1559, which secured a lease of the rectory for sixty years, with the proviso that they erect a grammar school within two years. Early vestry minutes record preparations for the founding of the school 'in the chorche howse late in the parryshe of seynte Margeretts', with a directive that 'the old chappell be hynd the chanesell shale be lett owghte toward the benyffytt of the same skoole'. In 1562, a licence was obtained, and Mathew Smyth was paid £40 for a schoolhouse in part of the Green Dragon inn, marked on the 1542 Plan of Southwark directly south of the church, on the west side of what is now Borough High Street. A hostelry connection continued with endowments made by Gilbert Rockett of Bankside's Three Tuns in 1587, Hugh Browker of the Red Lyon in 1608, and Gregory Franklin of his tenements behind the Queen's Head, in 1615, both in Borough. The school was rebuilt in 1676, after the Green Dragon was razed in the Great Fire of Southwark. In 1838–39, when its site was required for the enlargement of Borough Market, the school relocated to a new building on the north side of Sumner Street next to St Peter's Church, south of today's Tate Modern art gallery, on a piece of land purchased from the Bishop of Winchester.

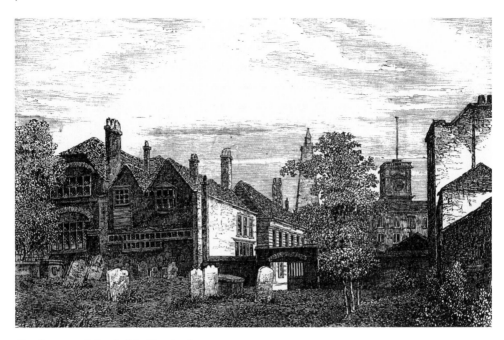

The Grammar School of St Olave's, 1810.

The will of Southwark beer brewer Henry Leeke, proved on 13 April 1560, bequeathed £8 toward the construction and maintenance of a new free school in the Parish of St Olave, to be transferred to St Saviour's if not founded within two years; the wardens of St Olave's Church were directed to 'prepare' a schoolmaster by Michaelmas Day 1561. Its status was upgraded by Letters Patent in 1571, when Queen Elizabeth's Free Grammar School was founded – paid for by the parish – on the east side of St Olave's churchyard, with new buildings erected in 1609. The school survived the Great Fire of Southwark, and was expanded and renovated soon afterward. It was demolished in 1829 to make way for the approach to the new London Bridge, its materials sold at auction on 19 January 1830.

The pupils transferred to new premises, first in Bermondsey Street in 1834–35, then in today's Queen Elizabeth Street in 1855, rebuilt to a classical design reminiscent of the late seventeenth century by Edward William Mountford, architect of the Old Bailey. St Olave's was united with St Saviour's Grammar School in 1899, and relocated to Orpington in 1968.

Philanthropic individuals and civic charities were of vital support to parochial 'good works', arming children with occupational skills to prevent them from 'falling upon the parish' as adults. In his 1766 *Survey*, John Entick reports that St Thomas' parish had 'a school, supported by private contributions, for the educating, clothing, and putting apprentice 30 boys'; St George's, 'a charity-school for 50 boys, maintained by subscription'; Bermondsey St Mary Magdalen, 'a charity school for 50 boys; and another for 20 girls; supported by voluntary subscriptions and collections at charity sermons: and a 'free-school for 50 boys founded by *Josias Bacon*'; and St Olave's, 'a charity school for 40 boys another for 60 girls'. For St Saviour's in Borough, Entick recorded

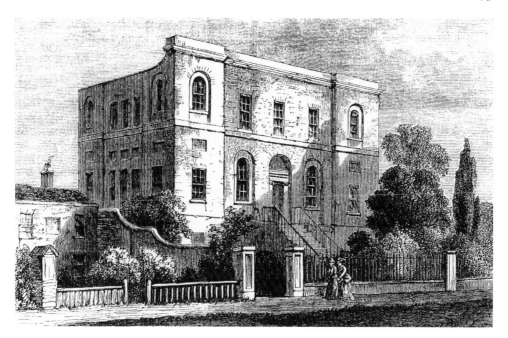

The Freemason's Charity School, 1800.

a *free English school*, founded by *Dorothy Applebee*, about the year 1681, for 30 poor boys of this parish, to be taught to read, write, and cypher; for the maintenance of which she appropriated 20l. [£20] *per annum*, out of an estate in *Fishmonger-alley*, by *St. Margaret's hill* ... In *Three-ton-alley* is a free-school for 50 girls, that are taught and cloathed by subscription. In *Angel-court* is a free-school for 80 boys of this parish, who are educated and cloathed: and there belongs to it a freehold estate, and it has a voluntary contribution besides.

Founded in 1788 to protect and reform deserted and vagrant children who were 'the offspring of convicted felons' or had 'themselves been engaged in criminal practices', the Philanthropic Society leased ground in St George's Fields, near the London Road, from the City Corporation in 1793, where it erected houses and workshops, acquiring further plots in 1805 and 1811. The institution trained up boys as craftsmen and girls as 'menial servants', their work initially generating an income for the society; however, declining profit during the 1840s caused its remit to be reduced to 'the Reformation of criminal Boys', and in 1849 the school was moved to Redhill in Surrey, where the pupils carried out agricultural work. It was also in 1788 that the Royal Freemasons' School for Girls in St George's Fields was first opened in temporary buildings rented from James Hedger of the nearby Dog & Duck spa, before a lease of its ground was secured on what is today the north side of Westminster Bridge Road, and a school for the education of up to 100 children was built. There, the daughters of masons of at least three years' standing, with a clean bill of health, were admitted aged five to ten to learn needlework and domestic skills, then apprenticed at the age of fifteen, having acquired 'a due sense of subordination, in true humility and obedience to their superiors'. The school was moved to Wandsworth in 1852.

The School for the Indigent Blind (known today as SeeAbility) was opened in 1800 at the Dog & Duck, which had closed as a pleasure garden the previous year, with fifteen pupils receiving instruction in its Long Room. The tavern's lease was secured from its proprietor, James Hedger, soon after, and the student body quickly expanded to thirty-five boys and seventeen girls, who received clothing, food, and lodging, as well as education. The City Corporation's plans to let the site to the governors of Bethlem Hospital when its lease expired in 1810 prompted the school's relocation to a newly erected building in 1811–12, between Lambeth and London roads; its permanent home was established in Leatherhead in 1900.

Numerous almshouses were erected in Southwark from the second half of the sixteenth century onward, both by private individuals and institutions. Thomas Cure, saddler to Queen Elizabeth I, founded his college for the Poor of St Saviour's parish in Dead Man's Place in the Liberty of the Clink in 1584. Entick's *Survey* records that 'it consists of 16 rooms for as many poor men and women, each of whom hath 20d. *per* week', and that 'In the church-yard are two rooms for two poor people, founded by Mr. *Henry Jackson, anno* 1682. each of whom hath 20d. *per* week. Also two houses founded by *Henry Young*, Esq; who endowed them with 5l. [£5] 4s. *per annum*, paid weekly.' In 1616, the Elizabethan actor Edward Alleyn also erected almshouses in Dead Man's Place, in Soap Yard; they were amalgamated with Cure's College in 1862 and relocated, first to nearby Gravel Lane, then to West Norwood in 1866.

DID YOU KNOW THAT...?

Though unsuitable for residential building, the construction of roads across the marshy ground of St George's Fields during the mid-eighteenth century enticed numerous charities to erect premises on its low-cost plots, more than fifty years before the land was drained.

The Fishmongers' Almshouses were built in 1615 at the corner of St George's Road and Newington Butts, on land bequeathed by livery man Sir Thomas Hunt to the Worshipful Company of Fishmongers on condition that they 'build an hospital, containing houses for six poor freemen, and to have the houses rent free, and a yearly sum of 40s. a-piece, to be paid quarterly'. The antiquary John Aubrey recounts that it was King James VI and I who named it St Peter's Hospital 'as he came by it from *Scotland*, in allusion to St. *Peter*, the Tutelar Saint of the *Fishmongers'*. Additional buildings were erected in 1616, from the bequest of Robert Spencer. The hospital was comprised of twenty-two houses, a hall and chapel by 1636. Citizen and Fishmonger James Hulbert's legacy funded the construction of Hulbert's Almshouses on its south side in 1719. Entick describes St Peter's as 'a handsome building, with a pair of iron gates, which open into the center of the building. ... This part is an ancient *Gothic* structure, with a brick wall before it. There is another part more modern, and founded by Mr. *James Hulbert*, for the accommodation of 20 poor men and

The Fishmongers' Almshouses, 1850.

women of the fishmongers company, endowed in the same manner as the former'. Their inhabitants were relocated to Wandsworth in 1851, and the almshouses demolished.

When John Walter, clerk to the Drapers' Company, offered to fund the construction of almshouses to accommodate sixteen poor members of the company in the parish of St George the Martyr in 1642, subject to the parish providing the land and maintaining the buildings once erected, its parishioners secured 'a wast peece of ground lyeing between the pound and the style' from the City, 'att the entrance into St. George's fields', near today's junction of Borough Road and Borough High Street. In 1653–54, further ground was taken out of the pound to provide the Drapers', aka Walter's Almshouses, with a chapel and a room in which pensions were distributed by the trustees. In 1766, Entick noted that close by 'on the south-west, near the turnpike, is a modern charity called the *Asylum*, or house of refuge for orphans and other deserted girls of the poor, under 12 years of age, to preserve them from the miseries and dangers to which they would be exposed, and from the guilt of prostitution'. During the 1770s, the almshouses were rebuilt further back from their original position, which was absorbed into the new Borough Road; when the latter was redeveloped in 1819–20, the City relocated the inhabitants to a new site between King's Bench and Glasshill Streets, where it erected a row of five two-storey brick houses, with an ornamental front garden and wash houses to the rear, next to almshouses built by the Revd Rowland Hill, whom we met as the founder of the octagonal Surrey Chapel. They were established in 1812 in Gravel Lane, for the accommodation of twenty-four widows of his congregation. Revd Hill's almswomen were transferred to Ashford during the early twentieth century, and the Drapers' residents to Walters Close in Walworth in 1973.

Hopton's Almshouses.

Although a resident of Westminster, Charles Hopton Esq., Gentleman and Freeman of the Fishmongers' Company, owned copyhold land in Southwark's parish of Christchurch near the Pudding Mill, and by his will of 1730 funded the construction of what Entick describes as 'a neat spacious building, situated about 200 yards to the east of this church ... for 26 poor men, who have been housekeepers, and come to decay; each of whom has an upper and lower room, with 10l. [£10] *per ann.* paid monthly'. While almsmen were allowed to marry, the rules precluded their children from becoming chargeable to the parish. Dating to 1752, it is a rare survival set within a sea of modern edifices south-east of Blackfriars Bridge.

The cottages have remained in continuous occupation ever since, with two additional almshouses built in 1825. Under the management of the United St Saviour's Charity, the estate was modernised in 1988 and renovated in 2013, its twenty one-bedroomed units now available to residents over the age of sixty who have lived in Southwark for at least three years.

In 1805, eight cottages were built on Webber Row in St George's Fields, which became known as Hedger Court in honour of their founder, James Hedger. In his almshouses, women over the age of fifty could 'enjoy freedom from worldly care ... live in mutual affection ... [and] contemplate their eternal happiness', with priority given to the widows and daughters of his former tenants, one of whom was elected matron. Until its lease expired in 1895, when the almswomen moved to new premises in Lambeth, the trustees provided a roast beef dinner and entertainments on the anniversary of Founder's Day – perhaps a happy consequence of that founder also having been the landlord of the Dog & Duck.

6. Historic Inns and Industry

'Longe Southworke' and St Margaret's Hill – today's Borough High Street – evolved as a continuation of London Bridge, the only causeway over the Thames until the opening of Westminster Bridge in 1750; a surfeit of inns lined the thoroughfare to accommodate visiting diplomats, traders, and assorted travellers between London and England's coasts. Tenements were erected on either side of their yards, which developed into narrow courts and alleys, those on the western side backing onto the Bishop of Winchester's park. Describing the eastern side, from south to north, in his *Survey* of 1598, John Stow remarked on the 'many fair inns, for receipt of travellers, by these signs, the Spurre, Christopher, Bull, Queene's Head, Tabarde, George, Hart, Kinge's Head, &c'. A survey of Southwark dating to 1555 lists sixty-five inns, taverns, brewhouses, and backhouses either side of London Bridge, extending through the Queen's Manor, the Gildable Manor, and the Great Liberty to Bermondsey, the vast majority unsurprisingly lost to time. The Bear at Bridge-foot, abutting Montague Close to the east, dated from the early 1300s, with taverner Thomas Drynkewatre leasing it to James Beaufleur in 1319. It was frequently celebrated in popular ballads – in 1691, the poem 'The Last Search after Claret in Southwark' called the Bear 'the first house in Southwark built after the flood', before it was demolished in 1761 to make way for the enlargement of London Bridge.

DID YOU KNOW THAT...?

The Boar's Head inn was once owned by Sir John Fastolf, who fought courageously in the French Wars as a general under King Henry IV, while his namesake, the charismatic scoundrel Sir John Falstaff, was a 'regular' at the Boar's Head in Eastcheap in Shakespeare's *Henry IV Parts 1 and 2*.

Nearby to the south, the Boar's Head stood on the eastern side of the High Street; it is first mentioned in a letter from Sir John Falstolf's servant to John Paston in 1459, requesting that his master be reminded of his promise to make him the tavern's host, the outcome of his entreaty unknown. The history of Southwark's Boar's Head has been obscured by the fame of its namesake in Eastcheap and the Boar's Head inn yard at Whitechapel, where the Queen's Men performed after their departure from the Rose Theatre; by 1720, only its courtyard survived, the last vestiges removed in 1830.

Continuing south, the King's Head – known as the Pope's Head prior to the Reformation – is marked on the 1542 Plan of Southwark, its sign having been a bust

The Old King's Head.

of King Henry VIII; at the beginning of Queen Elizabeth's reign, it was owned by her saddler Thomas Cure, who founded his college for the poor in Dead Man's Place in 1584, before selling the King's Head to the Humble family in 1688. The tavern was burned to the ground during the Great Fire of Southwark in 1676, and rebuilt. It was leased to Henry Thrale of the Anchor Brewery and his successors, Barclay Perkins & Co., by St Thomas' Hospital during the eighteenth century. In 1879–81, Roman remains were discovered on the site, which suggest it had been inhabited since the Roman occupation. Its remnants were demolished in 1885 and rebuilt again, with most of the buildings both in and either side of King's Head Yard destroyed in the Blitz of the Second World War. Today's Old King's Head stands on its original site.

Standing on its south side, the White Hart (badge of King Richard II) is first mentioned in the historical record in 1406; it also features in a letter to John Paston, written in 1465 by Sir John Fastolf's servant John Payn, who lived in Stoney Lane off Tooley Street, recounting his misadventures at the inn, where Jack Cade had set up his headquarters during his occupation of Southwark in July 1450, as featured in William Shakespeare's *King Henry VI Part II*:

> the capteyn that same tyme lete take me atte Whyte Harte in Suthewerk, and ther comandyt Lovelase to dispoyle me oute of myn aray, and so he dyd. ... Item, the capteyn sent certeyn of his meyny to my chamber in your rents, and there breke up my chest ... and ther wolde have smetyn of myn hede, whan that they had dyspoyled me atte White

Hart. And there my Maister Ponyngs and my frends savyd me, and so I was put up tyll at nyght that the batayle was at London Brygge; and than atte nyght the capteyn put me oute into the batayle atte Brygge, and there I was woundyt, and hurt nere hand to deth; and there I was vj oures [6 hours] in the batayle.

It too was destroyed in the Great Fire of Southwark and rebuilt, with John Strype describing it in 1720 as 'very large and of a considerable trade, being esteemed one of the best inns in Southwark'. Charles Dickens set the famous meeting between Mr Pickwick and Sam Weller in the yard of the White Hart in chapter ten of his first novel, *The Pickwick Papers*, in 1836. It was demolished in July 1889, its name living on in White Hart Yard and the plaque commemorating its literary celebrity.

Standing next to the White Hart, the George – known by its sign of St George on horseback spearing the dragon, even after losing its saintly prefix at the Reformation – is the only surviving galleried coaching inn in London, whose layout would have been shared by its now absent neighbours. Guests would have been entertained by strolling minstrels and players, its first- and second-floor galleries, which fronted bedrooms, allowing the courtyard to be used as a 'pop-up' theatre, in turn influencing the design of the new indoor playhouses at the Blackfriars and Whitefriars. By the eighteenth century rooms at the inn, rather than its courtyard, were hired for the performance of 'Humours or Drolls' – invented by Robert Cox during the Civil War-era persecution of the Stage by

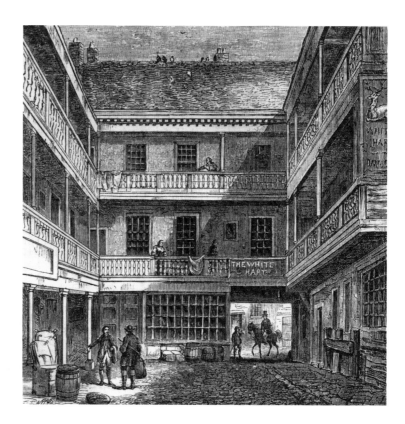

The Old 'White Hart' Inn.

Puritans – as well as temporary booths erected in the back inn yard, as we have seen with Mrs Mynns, whose son-in-law published Drolls in the alley behind the Blue Maid, further south. The George was razed with the rest in 1676, but reopened the following year – in 1825, it was reported to be a 'good commercial inn in the Borough High Street, well known whence several coaches and many wagons depart laden with the merchandise of the metropolis in return for which they bring back from various parts of Kent, that staple article of the country, the hop, to which we are indebted for the good quality of the London Porter'. The inn-keeping trade declined with the opening of the railway, which made the transportation of goods by coach and travellers' need for lodgings obsolete. William Rendle dreaded the loss of the George and its galleries in 1888: 'That which still exists is often made pretty in summer with flowers ... The parts of the inn not devoted to important business are mostly occupied by people who frequent the very bustling Borough Market close at hand. But alas, like the rest, the glory of this inn is departing! it's fate is sealed, it will soon be pulled down altogether.' Happily, Rendle's fear was misplaced: the George has been protected by the National Trust since its purchase in 1937. Today, a plaque celebrates its enduring history: 'Both Shakespeare and Dickens knew the hospitality of the inn which has continued right up to the present day.'

Next door to the George, the Tabard Inn was frequented by pilgrims travelling to the shrine of Thomas à Beckett, as immortalized by Geoffrey Chaucer in *The Canterbury Tales*:

The George Inn.

Bifel that, in that sesoun on a day,
In Southwerk at the Tabard as I lay
Redy to wenden on my pilgrimage
To Caunterbury with ful devout corage ...
The chambres and the stables weren wyde,
And wel we weren esed atte beste.

It had been established by 1307, when the Abbot of Hyde obtained a licence from the Bishop of Winchester to erect a chapel at or by the hostelry. John Stow's *Survey* confirms that 'Within this inn was also the lodging of the abbot of Hide (by the city of Winchester), a fair house for him and his train, when he came to that city to parliament, &c.' Stow reports that of all the inns that lined the High Street in 1598,

the most ancient is the Tabard, so called of the sign, which, as we now term it, is of a jacket, or sleeveless coat, whole before, open on both sides, with a square collar, winged at the shoulders; a stately garment of old time, commonly worn of noblemen and others, both at home and abroad in the wars, but then (to wit in the wars) their arms embroidered ... that every man by his coat of arms might be known from others: but now these tabards are only worn by the heralds, and be called their coats of arms in service.

It was rebuilt after the Great Fire of 1676, when it became known as the Talbot (a breed of hunting dog). In 1842, the Victoria Theatre (now the Old Vic) staged *Mary White, or the murder at the Old Tabard*, a melodrama set in 1543 in which the inn's virtuous barmaid, Mary, is tried for a murder she did not commit, but saved at the stake just before it is set alight, when the gypsy Savage Sam exposes the true culprit, with 'Innocence Triumphant'.

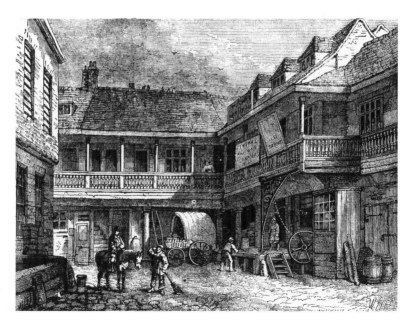

The Old 'Tabard' Inn, 1873.

Another casualty of London Bridge station, the Talbot had been converted into stores by the time the property was advertised for sale in 1865; it was sold again in 1873, and demolished in 1875. Medievalist and former Python Terry Jones unveiled a blue plaque commemorating Chaucer's association with the Tabard, mounted on the oldest building in Talbot Yard, on 23 November 2003.

The coaching inn known by its sign of the Half Moon stood south of the Marshalsea, between the Blue Maid and the White Cocke in the Hoope, from at least 1550, its tenements to the rear later leased to hop factors as well as livery stable keepers; it was demolished in 1919. The Angell Inn, adjoining the First King's Bench to the south, was converted to hold its prisoners during the reign of King Henry VIII, with the White Lion similarly used as a gaol from the second quarter of the sixteenth century, as we have seen. The Katherine Whele, first mentioned in the Manorial Survey of 1555, is the most famous of the inns on the west side of the High Street, standing opposite the Half Moon. Strype noted in 1720 that it was 'very large and well resorted unto by *Coaches, Waggons* and *Horsemen*'; pictured on page 37, it was demolished *c*. 1870.

Thirteen years after the Great Fire of Southwark, which decimated the north end of the High Street, an equally devastating inferno broke out on the night of 22 September 1689 in a shop cellar on its western side, opposite the First King's Bench; it swiftly razed Southwark Fair's wooden booths on the west, before spreading east, where 'Buildings, being Timber for the most part, and generally old, with many intricate Alleys running backward, the Flame, driven on by the Wind raged extremely', destroying approximately 180 houses along with part of the King's Bench, the Half Moon Inn to the north, and the Falcon Inn to the west. When Borough High Street was rebuilt, more space was accorded to its courts and alleys to alleviate what had proved to be fatal overcrowding.

Bankside, like Borough, could boast its fair share of inns, though not of the coaching variety, serving pleasure-seekers rather than travellers. A second Falcon stood in the Manor of Paris Garden in the Liberty of the Clink, south-east of the Swan Playhouse,

The Anchor
Tavern.

above Falcon Stairs (recorded in the plan on page 44) – said to have been frequented by Shakespeare and his fellow actors, and now subsumed within the 'Shakespeare's Globe' site. Citizen and Haberdasher John Hayward and his son Henry leased the Falcon Inn from the Bishop of Winchester, rebuilding it c. 1690, together with the adjoining building, which we have already met in the form of the house at Cardinal's Wharf whose plaque lays dubious claim to Sir Christopher Wren as its resident during the construction of St Paul's Cathedral.

Walking eastward along Bankside, we encounter the Anchor Tavern, once the tap pub of the Anchor Brewery, erected between 1770 and 1775 by William Allen on the site of an older alehouse called by its sign of the Castle. Nearby to the east, on Clink Street, at the south-west end of the dry dock where the reconstruction of the *Golden Hinde* is berthed, stands the Old Thameside Inn. Not quite so old a hostelry as its name implies, it was opened in 1985, the flagstone floor and heavy timbers retained from the building's previous incarnation as a spice warehouse at Pickfords Wharf adding historic interest to its superb view of the riverscape.

As already noted, and as remains the case to this day, several inns within the same borough could share the same name. On 14 November 1788, widow Elizabeth Atkinson insured her property with the Sun Fire Office, identifying its position as 'near the White Hart in Gravel Lane Southwark', on the north-east corner of George (today Dolben) Street, where the author and advocate of women's rights Mary Wollstonecraft lived at No. 45 from 1788 until 1791, writing her only children's book, *Original Stories from Real Life* (illustrated by William Blake), there, as well as *Vindication of the Rights of Man*; her daughter Mary Godwin lived nearby with her lover, the poet Percy Bysshe Shelley, in 1814, in Nelson Square, south of the White Hart. The inn itself was insured from 1804 – on 27 May 1835 by victualler John Beard, who produced spoof currency dated

The White
Hart.

5 November in the same year, which the London Metropolitan Archives describes as 'in general appearance not dissimilar from a Bank of England note'; it represents a 'Promise to supply to Bearer a Quartern of Cream of Gin, for 3½ or of Pure Old Jamaica Rum, for 4.d of the finest Quality or pay on demand the Sum of Fifty Pounds', and is headed 'Bank of Bacchus, White Hart, 21 Gravel Lane, Southwark'. Its address was changed to No. 22 Great Suffolk Street on 7 July 1935, where it remains today.

Southwark's position on the south bank made it a centre for maritime commerce as well as hospitality and entertainment, with fishing still a staple occupation during the eighteenth century. The proximity of the ships that imported raw materials from around the globe enticed both native and foreign craftsmen to construct a diverse array of workshops there, which dominated the waterfront until the 1970s, when its warehouse industry was relocated to the mouth of the Thames.

While John Squibb's lease of the property reveals that a pothouse and glasshouse (glass-blowing works) had been built on the site of the old Hope Theatre by 1671, a local token book dating to 1615 includes an entry for John Leech, styled 'Clerke of ye glasshouse', under the section headed 'Winchester house', which had recently been divided into workshops and tenements, revealing that the industry was already well established at Bankside. John Bowles built additional glasshouses near Squibb's during the late seventeenth century, in what came to be known as 'Glasshouse Square', replaced by a smithy and iron foundry by 1776. Stephen Hall, glassmaker, owned a workshop on the eastern portion of the Bishop of Winchester's estate during the eighteenth century, its site subsequently occupied during the nineteenth century by the Phoenix Gas Co., one of the earliest gasworks in England, followed by the South Metropolitan Gas Co., prior to the erection of Bankside Power Station, which now houses the Tate Modern. The Falcon Glasshouse, which took its name from the nearby inn, appears in the historical record from 1718; it was purchased by Pellatt and Green (later Apsley Pellatt & Co.) in 1803, which relocated the works to a site now occupied by Bankside Lofts on Hopton Street, north of the almshouses, where they manufactured high-quality flint glass, moving again in 1878 to Pomeroy Street, off the Old Kent Road. Founded during the fourteenth century, The Worshipful Company of Glaziers and Painters of Glass is based in the only Livery Hall located south of the Thames, ironically in a borough which had historically lain outside its jurisdiction, as beyond the City boundary. 'Outlaw' glaziers and glass painters could, however, produce as accomplished work as members of the Guild, whose pre-eminence had begun to wane by 1497, when Dutch-born Barnard Flower was appointed the King's Glazier – Flower described himself in his will of 1517 as 'dwelling w|ith|in the p|re|cynt of saint Thomas the Martir Hospitall in the Bur|ou|gh of Southwerk'. The Glazier's Company leased its site in Montague Close on the west side of London Bridge in 1975, restoring and converting the three-storey warehouse built by the Hays Wharf Co. during the Napoleonic Wars, a fitting embodiment of Southwark's cyclic reinvention.

Alexander Hay had purchased his small wharf during the mid-seventeenth century, and the company that came to bear his name once owned all the warehouses on the southern riverbank between London Bridge and today's Tower Bridge to the east, where Potters Fields lies on its western side. Labelled 'Potts Fields' on a map dating to 1682, its name commemorates the industry that once dominated this stretch of the bank, as glassworks had at Bankside; the parish registers of St Olave's Church reveal that 124 potters worked

Glaziers' Hall, with
Southwark Cathedral,
from the North Bank.

there between 1618 and 1710, decreasing to sixty-eight between 1710 and 1733, the industry defunct by 1772. The earliest named workshop was Pickleherring Pottery, established by Christian Wilhelm in 1612 – surviving examples of its ceramics are displayed at the Victoria and Albert Museum – which gave its name to Pickleherring Street, north of Potters Fields, running west to Pickleherring Stairs, roughly halfway between Tower and London bridges, where HMS *Belfast* is moored today.

Numerous corn wharves and granaries also lined the riverfront, including that of Alexander Hay, who initially launched himself as a brewer, before letting out the distillery to concentrate his energies on the more profitable storage arm of his business. Yet these mills had long been vital to the local production of food as well as beverages, as John Stow makes clear in his *Survey* of 1598:

> There are also divers garners [along the river], for laying up of wheat, and other grainers for service of the city, as need requireth. Moreover, there be certain ovens built, in number ten, of which six be very large, the other four being but half so big. These were purposely made to bake out the bread corn of the said grainers, to the best advantage for relief of the poor citizens, when need should require.

When Albion Flour Mills opened at the south-east corner of Blackfriars Bridge in 1786, sightseers flocked to view it as a triumph of industrial engineering, described by Thomas Allen in 1829 as 'furnished with a steam engine, contrived by Messrs Boulton and Watt of Birmingham, which turned ten pair of stones, each grinding nine bushels of corn in an hour without intermission, day or night; besides which it gave motion to the various apparatus for hoisting and lowering the corn and flour into and out of the barges, for fanning the corn to keep it free from impurities, and for sifting and dressing the meal, from its first state, till perfectly cleared for the use of the baker'. The poet William Blake, who lived in nearby Lambeth, was famously critical of 'these dark Satanic Mills' of the Industrial Revolution,

ATTIC MISCELLANY.

CONFLAGRATION! or the MERRY MEALMONGERS,
A New dance, as it was performed with Universal Applause, at the Theatre Blackfriars March 2.ᵈ 1791.

Conflagration! or the Merry Mealmongers, 1791.

with one theory ascribing the inspiration for his 'Jerusalem' mills to those of Albion, both tantalisingly present in the name – though not the theme – of his prophetic work *Jerusalem, The Emanation of the Giant Albion*. Although its steam engines did drive a number of traditional wind- and water-driven mills out of business, Albion's impact was curtailed on 2 March 1791 by its destruction in a fire suspected by some to have been deliberately started, but which owner Samuel Wyatt and engineer John Rennie believed was caused by friction.

The Thames being at low tide, the heat built to such intensity that fire engines were unable to reach it. Crowds gathered on Blackfriars Bridge to watch, and a cartoon in the *Attic Miscellany* lampooned the '*New dance*' called '*Conflagration! or the Merry Mealmongers*', '*performed with* Universal Applause, *at the Theatre* Blackfriars'. Independent millers carried celebratory placards reading 'Success to the mills of ALBION but no Albion Mills'. Their wish was granted, as its shell stood derelict until it was demolished in 1809.

Seventy years after the blaze at Albion Mills, a conflagration was sparked at Cotton's Wharf, near St Olave's Church on the riverbank west of London Bridge, on 22 June 1861, which became known as 'the Great Fire of Tooley Street'. Victorian poet and lawyer Arthur Munby recorded in his *Diary* that

For near a quarter of a mile, the south bank of the Thames was on fire: a long line of
what had been warehouses, their roofs and fronts all gone; and the tall ghastly sidewalls,
white with heat, standing, or rather tottering, side by side in the midst of a mountainous
desert of red & black ruin, which smouldered & steamed here, & there, sent up sheets of
savage intolerable flame a hundred feet high.

According to *The Times*, the wharf had stored roughly 5,000 tons of rice, 10,000 barrels
of tallow, 1,000 tons of hemp, 1,100 tons of jute, 3,000 tons of sugar, and 18,000 bales of
cotton. Smoke was seen billowing from the first floor of a warehouse holding hemp and
jute around 4 p.m.; within two hours fourteen fire engines were on-site, though it took
two weeks for the inferno – described as second only to the Great Fire of London – to
fully die out, its heat so intense that firefighters were initially restricted to hurling water
around its periphery. The combustible nature of the inventory caused the blaze to spread
fast and far, razing 11 acres up to a quarter-mile distant from Cotton's Wharf, including
the warehouses at Hay's Wharf to the east and Chamberlain's Wharf to the west, and
threatening to engulf London Bridge station, as *The Times* graphically reported:

On it seemed to come, nearer and nearer, with a crackling roar that was terrible, with
its millions of burning flakes filling the air as if the very atmosphere was on fire, and
the great ranks of red flame flapping about their keen thin points with a dull noise, and
leaping up high over the houses with bounds and spurts like fountains of fire.

Luckily, the wind changed course, redirecting the flames away from the station. London Fire
Brigade's Superintendent James Braidwood was buried under the brick wall of a warehouse
that collapsed in an explosion, his men unable to retrieve his body for three days due to the
extreme heat – his heroism is commemorated by a marble plaque on the side of a building on
Tooley Street, facing Cottons Lane. With damages amounting to approximately two million

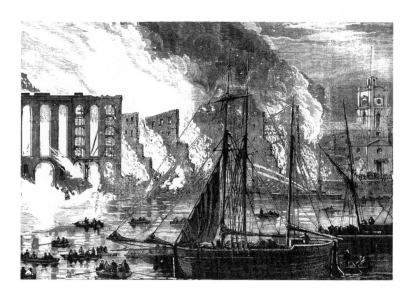

The Great Fire
at Cotton's
Wharf, 1861.

pounds, insurance companies raised their premiums and insisted on safer warehouse storage conditions, recommending to the Home Secretary in 1865 that responsibility for controlling fires within the burgeoning metropolis should be undertaken by a public authority. The Metropolitan Fire Brigade was duly established on 1 January 1866 by Act of Parliament.

Writing in 1766, John Entick leads us down from the wharves to reveal Southwark's prominence in the textile industry:

> On the south side, and about the middle of *Tooley-street, Barnaby*, or *Bermondsey-street*, runs southward. This is a spacious street, and inhabited by reputable people, especially in the hat-manufactory. ... The parish is supposed to contain 1900 houses, and a great quantity of garden-ground, tanners-ground, &c. and is divided into two precincts, *viz*. The *land-side* and the *water-side*.

The 'ey' in Bermondsey deriving from the Anglo-Saxon 'ei', its full name translates as Bermond's (originally Beornmund's) island, describing its position on marshy ground near the river.

DID YOU KNOW THAT...?

J. M. W. Turner painted *The Fighting Temeraire, tugged to her Last berth to be broken up*, depicting the veteran warship being towed to John Beatson's wharf at Rotherhithe under a romantically imagined sunset, from the riverside at Bermondsey in 1838.

Hatmakers, then known as feltmakers, had been working in the district since at least the sixteenth century: on 30 May 1592, the Lord Mayor of London wrote a letter to the Lord Treasurer reporting that

> Being informed of a great disorder and tumult in Southwark, he went there, accompanied by one of the sheriffs, and found a great multitude assembled, the principal actors being certain apprentices of the Feltmakers, out of Bermondsey Street and the Blackfriars, and a number of masterless men. ... He found it proceeded from the steps taken by the Knights Marshalsmen to serve a warrant from the Lord Chamberlain upon a Feltmaker's servant, committed to the Marshalsea with others, accused by the said Knights Marshalsmen to the Lord Chamberlain, as they alleged without cause of offence, for restraining of whom the apprentices and masterless men assembled themselves together, under pretence of their meeting at a play. ... He had been informed by the inhabitants of Southwark that the Knights Marshalsmen in serving the warrant used very violent means.

By the mid-1600s, Alexander Hay was trading in skins and hides at his wharf on the west side of London Bridge, to furnish the tanning industry, which had become centred at

Bermondsey due to its plentiful reserves of the oak bark needed for tanning and, most importantly, its steady supply of water from the river's tidal streams – likewise the sources of its eighteenth-century spas; during the Great Plague of 1665–66 Londoners hurried south to escape infection at its supposedly therapeutic tanning pits. The parish's tanners were incorporated by a charter of 1703, which specified that they must first have completed their seven-year apprenticeship in the craft. Charles Knight's 1842 edition of *London* notes that nearly all the metropolitan leather and wool factories stood in Bermondsey, whose Leather and Skin Market had been opened in Weston Street in 1833, superseding Leadenhall:

> A circle one mile in diameter, having its centre at the spot where the Abbey once stood, will include within its limits most of the tanners, the curriers, the fellmongers, the woolstaplers, the leather-factors, the leather-dressers, the leather-dyers, the parchment-makers, and the glue-makers, for which this district is so remarkable. There is scarcely a street, a road, a lane, into which we can turn without seeing evidences of one or other of these occupations.

The London Leather, Hide and Wool Exchange was built beside the market, to the north, in 1878 as a gentleman's club where business was transacted; a pub was included on the premises, as is still the case today. Changes to the manufacturing process, emerging

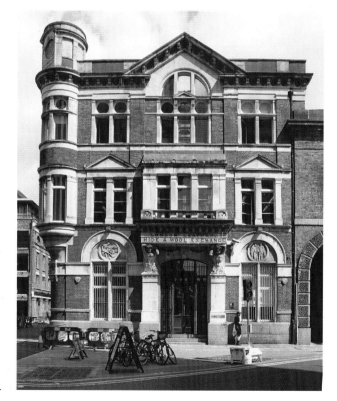

Leather, Hide & Wool Exchange.

motorised transport, and the development of synthetic materials led to the industry's decline in Bermondsey, though it remains a wholesale centre for imported leather goods; its manufacturing past lives on in the names of old inns east of the market, such as The Woolpack on Bermondsey Street and Simon the Tanner to the south on Long Lane. The Leather, Hide and Wool Exchange and most of the Leather Market, which sustained bomb damage during the Second World War, stand on their original sites today, converted into offices and studio accommodation.

Contemporary with Bermondsey's Leather Market and Exchange, Bankside's elegant neoclassical Hop Exchange was opened on newly built Southwark Street in 1868 to serve as a trading centre for the brewing industry, superseding the historic market in Little East Cheap, which entailed cartage from Borough over a congested London Bridge. Kent's 'hop garden' harvests were transported for storage in Borough's warehouses upriver by boat and by rail to London Bridge station, to be locally traded by merchants from their stalls under the natural light afforded by the glass roof above the Exchange's 'outcry floor'. Commemorated by a terracotta plaque on Borough High Street to 'HW & H le May Hop Factors', Mr Le May informed a Select Committee in 1890 that the scheme had quickly miscarried:

> The Hop Exchange was started with the idea of having an open market for hops, that the brewers should come and buy off merchants in the open market. The reason why it failed was because the brewers objected to buy off the merchants in the open market: they preferred to buy through the ordinary channels through the merchant. All the stands were let: the small merchants took their samples and exhibited them but no customers came to buy them. The market lasted for something like 18 months ... the thing simply collapsed.

The structure was repurposed as office space and retitled 'Central Buildings', while the factors and merchants moved to warehouses down the street, where their business was conducted with greater success. As a result of enemy bombing raids and urban redevelopment, it is the only exchange of its type still standing today, though without its top two storeys, which were destroyed by fire in 1920. While it survived the Blitz, twenty-five of a total thirty-seven hop warehouses were obliterated, and the industry's centre shifted from Southwark to Paddock Wood in Kent, where they were rebuilt.

The Borough had an early tradition of brewing as a cottage industry, associated with the inns and homebrew pubs that lined the riverfront and High Street. As John Stow noted in 1598, 'Men of trades and sellers of wares in this city have oftentimes since changed their places, as they have found their best advantage. ... But the brewers for the more part remain near to the friendly water of Thames.' The Bishop of Winchester and the Prior of St Mary Overies had granted a licence to the brewers of Southwark in 1509 for their carts to have passage 'from ye Borough of Southwark untill the Themmys ... to fetch water ... to brew with', stipulating that they should not claim that passage as a highway. James Monger Sr founded the Anchor Brewery in 1616 on ground adjoining the Globe Theatre, later expanding to incorporate lands situated between Dead Man's Place and Globe Alley, including the site of the theatre itself. The brewery had passed through several hands, and undergone further expansion, before its then manager Ralph Thrale purchased it in 1729

The Hop
Exchange.

for £30,000, to be paid by instalments over a term of eleven years. It was inherited in 1758
by his son Henry, who erected a waterhouse to supply the brewery with clean water,
Southwark having long been a depository for Thames sewage – seventeenth-century
sewer commissioners' records reveal that the 'sweet' and the 'foul' sewers frequently ran
in close parallel, their openings lying next to each other at the river's edge. The Borough
Waterworks Co., founded in 1770, took over Thrale's waterhouse, building its works
behind the inn known during the fifteenth and sixteenth centuries as 'the Castell upon
the Ho(o)pe' (then a stewhouse), west of the Anchor Tavern.

DID YOU KNOW THAT...?

Although part of the foundations of the original Globe Theatre were discovered
underneath the car park behind Anchor Terrace in 1989, the historic building's
Grade II-listed status precludes extensive excavation.

Thrale's celebrated wife Hester believed that brewery hands unearthed the playhouse's
'remains' while clearing ground to create a garden for their home in Dead Man's Place:

For a long time, then, – or I thought it such, – my fate was bound up with the old Globe
Theatre, upon the Bankside, Southwark; the alley it had occupied having been purchased
and [the tenements] thrown down by Mr. Thrale to make an opening before the windows
of our dwelling-house. When it lay desolate in a black heap of rubbish, my Mother, one
day, in a joke, called it the Ruins of Palmyra; and after that they had laid it down in a

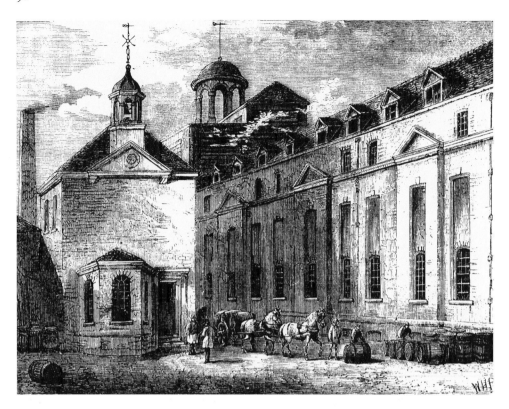

Barclay's Brewery, 1829.

grass-plot, Palmyra was the name it went by, I suppose, among the clerks and servants of the brew-house; for when the Quaker Barclay bought the whole, I read that name with wonder in the Writings. ... But there were really curious remains of the old Globe Playhouse, which, though hexagonal in form without, was round within.

When Mrs Thrale sold the Anchor at auction after Henry's death in 1781, her friend Samuel Johnson is reported to have said, prophetically, 'We are not here to sell a parcel of boilers and vats, but the potentiality of growing rich beyond the dreams of avarice.' It was purchased by Robert Barclay (of the merchant banking family) for £135,000, to be paid over four years. He entered into partnership with its manager, John Perkins, and refounded the brewery as Barclay Perkins & Co., enlarging it once again to incorporate the burial ground and meeting house in Dead Man's Place. By 1809, Barclay's had become the largest brewery in the world. A final noteworthy expansion took place in 1820, when Potts' Vinegar Yard, at the end of what is now Thrale Street, was leased to the firm by the Bishop of Winchester, its freehold acquired in 1864.

Vinegar had initially been malted as a bi-product of brewing, with dedicated works erected in close proximity to the breweries south of the river, the best known being Sarson's Vinegar factory on Tower Bridge Road, operational between 1794 and 1992 (now converted into offices and flats), close to the Courage Brewery, founded by John

Anchor Terrace,
Southwark
Bridge Road.

Courage at the Anchor Brewhouse in Horsleydown, near Tower Bridge, in December 1787. Barclay's Brewery was rebuilt after the destruction of numerous buildings – including the Thrales' dwelling house – by fire in May 1832, with Anchor Terrace erected on Southwark Bridge Road in 1834 to provide accommodation for its senior employees, converted into luxury flats during the late 1990s. Following its merger in 1955 with the Courage Brewery, Barclay's Anchor site continued in operation until the 1970s. It was demolished in 1981, though its tap Anchor Tavern still flourishes on Bankside, as we have seen. Courage's Anchor Brewhouse was reconstructed and transformed into luxury flats in 1985–89, its Anchor Tap pub today run by Samuel Smith.

A less salubrious river-based activity was immortalised in 1864 by former Southwark lodger Charles Dickens in the opening of *Our Mutual Friend*, as 'Gaffer' Hexham is rowed by his reluctant daughter Lizzie under the 'iron bridge ... towards the Surrey shore', a short distance north of Anchor Terrace:

> He had no net, hook, or line, and he could not be a fisherman; his boat had no cushion for a sitter, no paint, no inscription, no appliance beyond a rusty boathook and a coil of rope, and he could not be a waterman; his boat was too crazy and too small to take in cargo for delivery, and he could not be a lighterman or river-carrier; there was no clue to what he looked for, but he looked for something, with a most intent and searching gaze.

He was in fact a waterway highwayman, looking to pick the pockets of corpses floating in the Thames, the outlaw criminal, as ever in Southwark, co-existing with the outlaw visionary, just as inns had sat amid hospitals and gaols, and the stews beside the stages, which exhibited the crown jewels of England's drama.

Epilogue

Following the Civil War and Great Fire of London, Blackfriars and Southwark lost their shared correspondences, with one built anew, the other cyclically reinvented according to its ancient dynamic temperament, absorbing Blackfriars' theatrical past into its riverside landscape in the form of the Sam Wanamaker Playhouse, thereby preserving its legacy for generations to come – a tangible realization of its motto 'United to Serve'.

At a time of global turmoil, too often erupting in acts of violence such as the London Bridge and Borough Market terror attacks of 3 June 2017, it is through living up to Southwark's ideal of cross-cultural union in the service of others that we will succeed in the resolve not to let London Bridge, 'or any bridge, fall down'.

Commitment Locks, Bankside, west of London Bridge.

Bibliography

A History of the County of Surrey: Volume 4, ed. H. E. Malden (London, 1912).

A New and Accurate History and Survey of London, Westminster, Southwark, and Places Adjacent: Volume IV, Revd John Entick (London, 1766).

A Survey of London, Written in the Year 1598, John Stow (London, 1842).

Borough & Bankside Selected HAA Draft Issue 07, 22.12.15.

London: Volume III, ed. Charles Knight (London, 1842).

Medieval London: Volumes I & II, Sir Walter Besant (London, 1906).

Old and New London, A Narrative of Its History, Its People, and Its Places: Volumes I & II, Walter Thornbury (London, 1878).

Old and New London, A Narrative of Its History, Its People, and Its Places: Volume VI, Edward Walford (London, 1878).

Old Southwark and Its People, William Rendle (Southwark, 1878).

Shakespearean Playhouses, A History of English Theatres from the Beginnings to the Restoration, Joseph Quincy Adams (Cambridge, Massachusetts, 1917).

Survey of London: Volume 22, ed. Howard Roberts and Walter H. Godfrey (London, 1950).

Survey of London: Volume 25, ed. Ida Darlington (London, 1955).

The Conventual Buildings of Blackfriars, London, and the Playhouses Constructed Therein, Joseph Quincy Adams (Studies in Philology: Volume XIV, 1917).

The Inns of Old Southwark and Their Associations, William Rendle and Philip Norman (London, 1888).

The National Archives and London Metropolitan Archives.

About the Author

Kristina Bedford is a historical researcher whose independent business, Ancestral Deeds, specialises in the medieval and Tudor-Stuart periods. She has contributed to episodes of the genealogy documentary series *Finding Your Roots*, *Finding Your Past*, and *Who Do You Think You Are* (US), as well as being an occasional contributor to *Who Do You Think You Are* magazine (UK), answering reader questions on 'theatrical ancestors' and the English Civil War. She has authored several articles and books in the fields of theatre and local history, documenting Eltham and Woolwich for Amberley Publishing's *Through Time* series and, having crossed the Atlantic to study the theatre of Shakespeare in 1984, leapt at the opportunity to explore *Secret Southwark and Blackfriars* for Amberley today.